DATE DUE

OC 29 04			

DEMCO 38-296

THE COLD CHOICE

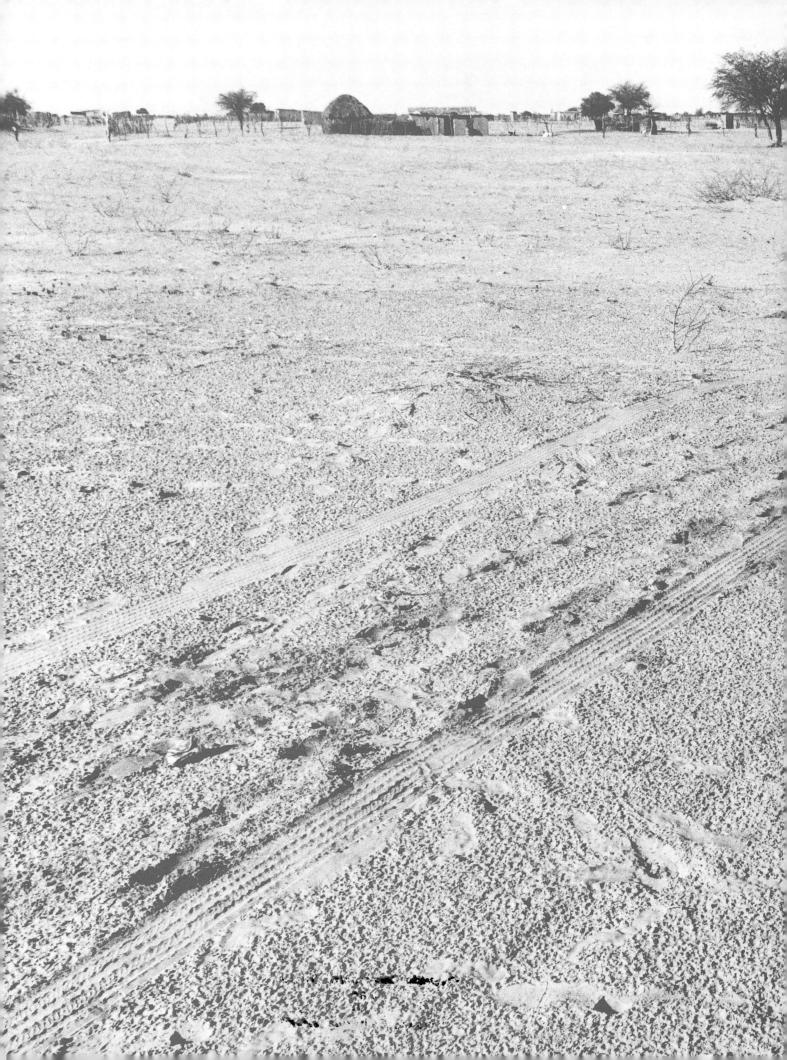

THE COLD CHOICE

Pictures of a South African reality

STRUAN ROBERTSON

DAVID PHILIP · Cape Town & Johannesburg
Wm. B. EERDMANS · Grand Rapids
AFRICA WORLD PRESS · Trenton, N.J.

This book is dedicated to all members of the family called Operation Hunger who, daily, must make the cold choice, often in the face of daunting adversity, between carrying on and giving up. I will always be grateful for the comradeship, hospitality and courageous example they have given me during the years we have worked together.

First published 1991 in southern Africa by David Philip Publishers (Pty) Ltd, 208 Werdmuller Centre, Claremont 7700, South Africa

Published 1991 in the United States of America by Wm. B. Eerdmans Publishing Co., 255 Jefferson Avenue SE, Grand Rapids, Michigan 49503; and Africa World Press, 15 Industry Court, Trenton, New Jersey 08638

ISBN 0-86486-171-0 (David Philip)
ISBN 0-8028-3694-1 (Wm. B. Eerdmans)
ISBN 0-86543-217-1 (Africa World Press)

Printed by Tien Wah Press (Pte.) Ltd, Singapore

Contents

Courage is a moral quality; it is not a chance gift of nature like an aptitude for games. It is a cold choice between two alternatives, the fixed resolve not to quit; an act of renunciation which must be made not once but many times by the power of the will. Courage is will-power.

— Lord Moran, *Anatomy of Courage*

Struan Robertson's record of six years of travel with Operation Hunger ensures our place in the artistic and photographic history of this country.

The sensitivity of his work is a clear expression of his caring and compassion; his anger at injustice; his resentment of the poverty he witnessed; and the joy he shared with us all when people began to walk tall, began to take their lives back into their own two hands.

The launch of this book coincides with Operation Hunger's completing ten years of service to the poor and the hungry of this land; ten years of striving to meet the needs that confronted us; ten years of responding, to the best of our ability, not only to the crises of drought and flood but also to the multiple appeals from individuals and communities who *normally* lack the basics that the rest of us take for granted – sufficient food, adequate shelter and the opportunity to achieve these by themselves.

This book spells it all out – the negatives, the positives; the things accomplished, the huge tasks that remain to be done if the massive economic deterioration of the black rural areas is to be halted.

It is imperative, at this point in time, that there be maximum awareness of the plight of the rural people. There is a real danger that the planning for South Africa's bright new future will make no provision for the largest percentage of the rural people – the functionally illiterate, the landless, the ultra-poor. There must be realistic land reform to enable them to remain on the land. There is a real danger that urbanisation, which is being offered as the universal panacea, will leave these people worse off than they were before. We at Operation Hunger hope that Struan's photographs and moving text will be a major thrust in the constant battle to remind the world of the other South Africa: the South Africa we work with.

We are deeply indebted to Marjorie Britten who edited Struan's manuscript with the meticulous care and devotion that has made her a legend. I should also like to thank John Kane-Berman, Executive Director, South African Institute of Race Relations, for putting his research and library teams at Marjorie's disposal to check every fact and figure.

Ina Perlman
Executive Director Operation Hunger

Acknowledgements

No book can be the unaided work of a single person. Many, many people helped me with this one. First I should like to thank the people in the relocation camps, townships and squatter camps who received me with courtesy and agreed to be photographed. Many Operation Hunger people are mentioned in the text, and to all of them I give my unreserved thanks for their help. I also thank Dr Frances D'Souza of the University of Oxford's Biological Anthropology Department for allowing me to accompany her survey. Other people, just as important, also deserve my thanks: Anne Scott who argued, nagged and cajoled to resolve differences and keep the project going; Norma Lancaster who was untiring in organising transport and accommodation; Karen Hollander who put the first draft on disc; and Moses Mokoena who drove me skilfully and safely many hundreds of kilometres. My thanks go to Marjorie Britten and the staff of the South African Institute of Race Relations for meticulously checking facts, as well as to Russell Martin for being a creative and understanding editor. Lastly I thank my wife, Elizabeth, for her patient support throughout the long years which finally brought this book to reality.

I must apologise to the reader for the use of such racial terms as 'black', 'white', 'coloured' etc. I would prefer to call everyone who owes allegiance to the land and spirit of Africa 'African' and all others 'foreigners'. Unfortunately the racially divisive policy of apartheid has caused most of the grief, hunger and desperation depicted in this book. To discuss these problems outside the racial divisions which gave rise to them would be meaningless. I therefore request the reader's patience with my use of the above terminology.

Purely for the sake of typographical convenience I have omitted quotation marks around the words independent and homeland where these refer to the semi-autonomous successors to the old Native Reserves. My use of those words, even without quotes, does not imply any approval whatsoever of the apartheid fictions they embody.

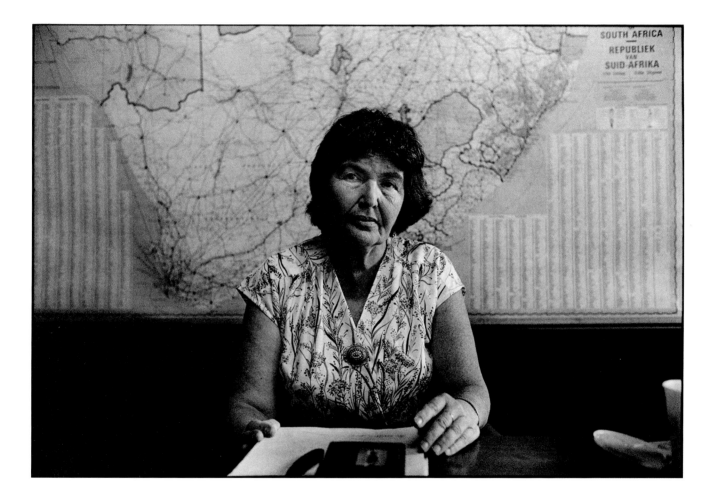

The word 'doughty' was invented for people like Ina Perlman. The *Concise Oxford Dictionary* gives 'doughty' as 'valiant, stout, formidable'. She is all of these and more.

Growing up in Port Elizabeth Ina saw, very early in life, the poverty which is endemic to the Eastern Cape. 'From the word go I was always acutely aware that there were kids in rags and that there were people who lived in bad conditions and that it was basically because they were black and for no other reason.'

Such insights led her to work with the African Children's Feeding Scheme, African Self-Help and, later, to join the Institute of Race Relations and become the Southern Transvaal regional manager.

Ina Perlman, Executive Director, Operation Hunger

Then, in 1980, came the drought in KwaZulu, the precursor of the countrywide drought later in the decade. 'All sorts of people were phoning the Institute and saying: "This is the time to get awareness going that this is not just a local drought, it's part of a huge endemic problem of hunger in the rural areas. Now is the time to get co-ordinated action going." At the same time Selma Browde and Nthato Motlana came to the conclusion that their Hunger Awareness project wasn't working and they came to the Institute to ask us to take over. So we called a meeting of all the organisations we could think of which would be concerned and the result was that ten of those organisations came together to form Operation Hunger.'

But Operation Hunger was not to be merely one more famine-relief scheme. 'From the word go we took the decision that feeding is a crisis-intervention strategy and that the long-term solution lies in self-help and development.' Even feeding itself was not to be a straight hand-out. 'We set the criteria that Operation Hunger itself must never run a feeding project, that the projects should never be called Operation Hunger projects.

'More than that we decided we would only respond to community request. Even if the request came from a church, we had to be sure that the community was interested and prepared to be involved.' The idea was not to impose feeding on a community but to work in partnership with the community. In this way even a feeding scheme could be the first step to self-help. 'You know, the community has to get its act together before we come in with even one bag of soup. This is very important.

'We are a body which works with the community. Operation Hunger doesn't teach, doesn't instruct, doesn't injunct, doesn't dominate. Our role must be totally underplayed. That's why we don't put fieldworkers in to run projects. It's fatal if they do; there's total proof of this from all the post-war experience where organisations put someone in for three years to run a project and then, when they left, the whole thing collapsed. Look, in South Africa we have to break down two hundred years of *ja, baas*. The most important thing in development work is humility; humility and the ability to listen.

'If you go into a group and they all stop and look at you, and if you take the lead at that point, you've lost them forever. All you're doing is transferring dependency from the government to your aid organisation. This may be very good for your ego, but it's not development.

'Again, you know, people sneer at the word "hand-out." But true development *is* a hand-out. The community puts out a hand, you take that hand, and you walk forward together. Preferably with you, the aid organisation, one step behind. Because, you know, there's got to be a total adaptation to the pace of the community, making sure they are with you all the way.'

With Operation Hunger coming more and more into contact with large overseas development organisations, the realisation is growing that the criteria these organisations apply to projects cannot always be followed in South Africa. 'In the South African context we very often can't apply strict rules of economic viability because of the lack

of good land. Very often one's got to work on survival strategies. One's got to be very careful before one uses words like "economic viability" or "turning communities around." In South Africa one has just got to realise that one cannot blueprint.

'Very often you go into something knowing that it's not the total solution, that it's nothing more than a help in people getting their act together, and that there are communities where even getting their act together will never be more than partial until there is a total revision in land-ownership and until there is a total revision of wage structures for the unskilled. Most of the time we're talking in survival strategies, we're not really talking in terms of economic turn-around.'

Does she ever get discouraged at the size of the problem? 'Obviously. But look, one thing I've learned: the essence of development is mini, not mega. It's all part of humility. There's an underlying arrogance about wanting to solve huge problems. This business of "It's too big for me to handle" is the best excuse for doing nothing. If you can get one village off the ground, or even fifty people in one village off the ground, that's something.

'I'm a firm believer in the drops-in-the-ocean concept, you know. Start. Do what you can and don't stop doing it because it's too big for you. I mean, personally, I don't think anyone will ever solve the problem of Botshabelo, but there are groups there one can work with. I'm fully aware that there are 350 000 people in the relocation camps of KwaNdebele, but, after five years, we have got 1 000 women involved in making beadwork for sale, which means that about 7 000 of those people, maybe 9 000, are feeling some sort of economic ripple. That's all you can do. The alternative is to do nothing.'

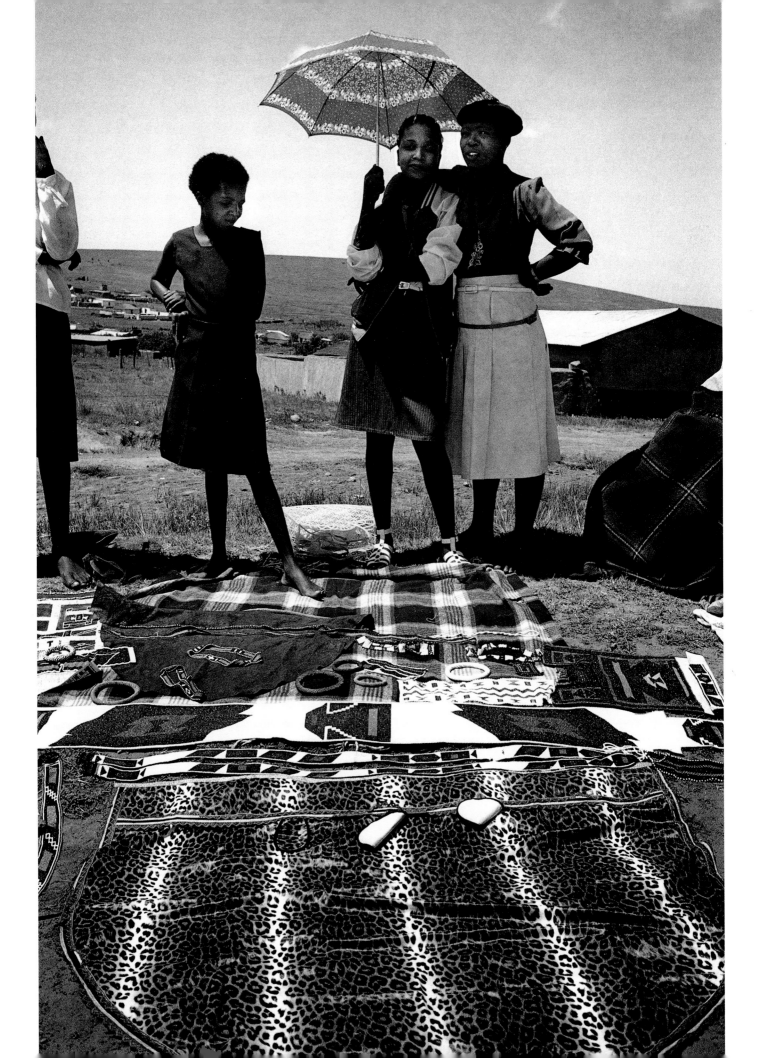

I have known Ina Perlman, the executive director of Operation Hunger, for years. Her husband, Michael, has a keen interest in photography and would often urge me to go and take pictures of Operation Hunger's work in the relocation areas, those rural slums where blacks considered unemployable and expendable by the white economy have been dumped.

◄ Young women and handicrafts, Monsterlus, KwaNdebele

For a long time I made various excuses not to. Firstly, like most whites in the early 1980s, I was more concerned with the ferment in the city townships. The rural areas seemed so distant, dreary and unimportant.

Secondly, I distrusted all charity feeding organisations. The sixties, like the eighties, was a decade of drought in southern Africa. Early in 1966 I had gone to Botswana (or, as it was then, Bechuanaland) on assignment for an English magazine. My brief was to get pictures of the drought as it affected the Batswana.

I visited two villages and was struck by the difference in morale of the two places. In the first village they proudly showed me how they had continued to cultivate their fields by ploughing with donkeys after the death of their oxen from thirst. When I told a black friend of this he was incredulous. 'Ploughing with donkeys? You can barely get a donkey to pull a cart, let alone a plough. They must have had to pull the donkeys and the plough.'

In the second village the oxen had also died but there the villagers had given up. They left their fields uncultivated and sat around listlessly day after day. The main difference between the two villages was that, while the people of the first village scratched a barely adequate living from the dry soil, in the second village several large trucks from a famine relief organisation arrived every Thursday morning.

This was the only time those villagers displayed any animation. Arguing and shouting, they organised themselves into queues to receive their bags of yellow corn-meal and their boxes of fortified milk-powder. After they had carried this food into their huts they sank back into apathy until next Thursday. It was a graphic illustration of the demoralising effect of food hand-outs.

Thus it was with less than perfect enthusiasm that I finally went along to see Ina. A week later, at 5 o'clock of a bright summer's morning, I found myself in a battered little white truck with the very

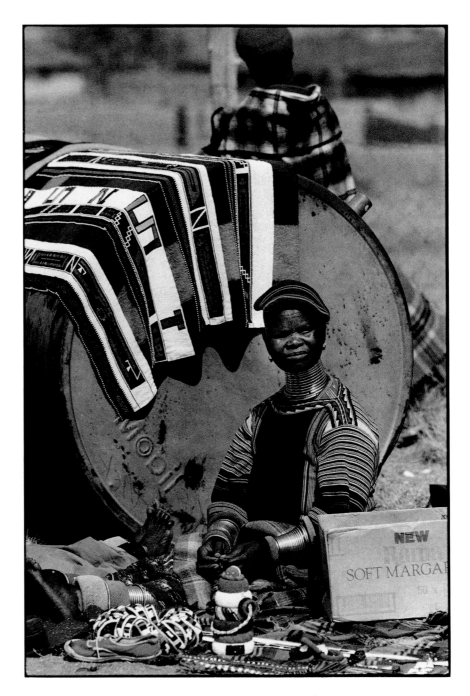

Ndebele woman and handicrafts,
Monsterlus, KwaNdebele

elegant Operation Hunger national crafts organiser, Dina Mabudafhasi, heading north out of Johannesburg on the freeway. We bypassed Pretoria, took the Witbank freeway and then turned north again at Bronkhorstspruit towards Groblersdal. As the narrow road spun out ahead into the sun-glare, I had no inkling that it was leading me not just to one KwaNdebele village, but to a South Africa I'd never seen before.

Because, if anyone had asked me, that bright January morning in 1986, I would have told them that I had photographed everything there was to photograph in South Africa. I had photographed the cities, the towns, the mountains, the plains, the deserts, the forests and the rivers. I had photographed the mines, the farms, the factories and the vineyards. I had pictures of black townships from

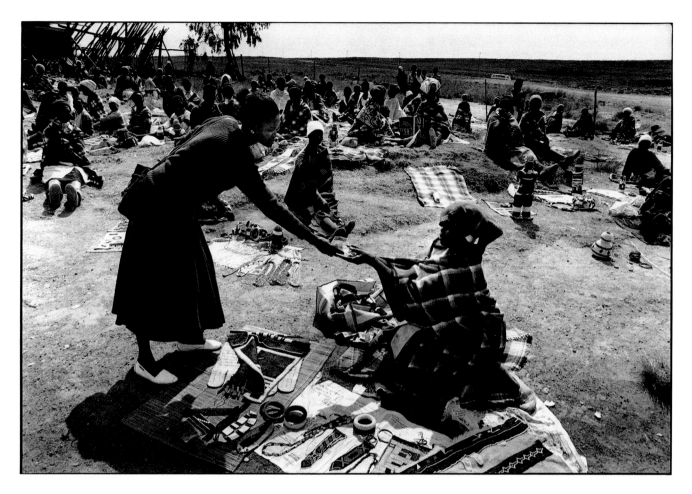

Dina Mabudafhasi of Operation Hunger buying handicrafts at Monsterlus, KwaNdebele

Soweto to Woodstock. What more, I would have said that morning, was there to photograph?

That road was to show me. It was the first leg of a three-year tour of South Africa like no other trip I had ever experienced. It was a tour of rural black South Africa, the South Africa created by apartheid policy. During that three-year journey I was to see more squalor, more desperation, more dignity and more courage than I had ever thought existed.

Far north of Groblersdal we came along a dusty gravel road to Monsterlus, a collection of tin-roofed mud huts on bare hills pressed up against the hot sky. As we approached I saw that, all around the general store and along the sides of the road leading to it, were hundreds of women, many in traditional Ndebele beaded blankets and brass neck-rings, each with bright patches of beadwork spread around them.

It was, on a much bigger scale, like those tourist traps you find at all the scenic lookouts in Natal where women importune you to buy knick-knacks. It was also, I first thought, pathetic because along this potholed backveld road no tourist would ever come. Then we pulled into the forecourt of the store and Dina got out of the truck. She began greeting the women, and I felt the hair on my neck stir in horror as I realised that those women were all there, in their hundreds, for us. We, in our little Operation Hunger truck, were the tourists. Those acres of beadwork were spread out for us to buy.

During the following hours Dina did just that, moving from group to group under the blazing sun. She studied workmanship, advised the women on improvements and innovations, and bought, bought, bought. By the time we left Monsterlus she had filled the truck with beadwork and had distributed over four thousand rands amongst that isolated community. Survival was assured until she returned a month later.

It was my first encounter with the self-help ethic. There were no hand-outs in Monsterlus and these women had a pride in their work and in themselves that was the antithesis of the hopelessness I had seen in that Botswana village twenty years before. This was famine relief with a difference. I was impressed.

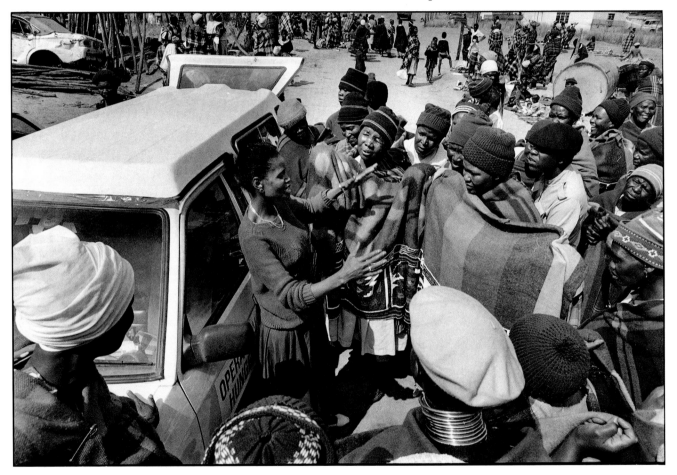

Dina Mabudafhasi talking to craftswomen, Monsterlus, KwaNdebele

Two and a half years later Dina again took me to Monsterlus. The whole scene was re-enacted just as Dina had been re-enacting it for every month of the intervening years. For all that time and more she had not merely kept Monsterlus in funds. She had also been giving those women a pride in their craftsmanship. More than that, she had been saving their heritage.

When the drought and economic depression first hit KwaNdebele, the women raised money for food by taking a long bus ride into Johannesburg and selling the beaded aprons Ndebele women hand down from mother to daughter. Dina, by encouraging the women to make aprons for sale and by guiding them in market fashion, has helped them save their family heirlooms.

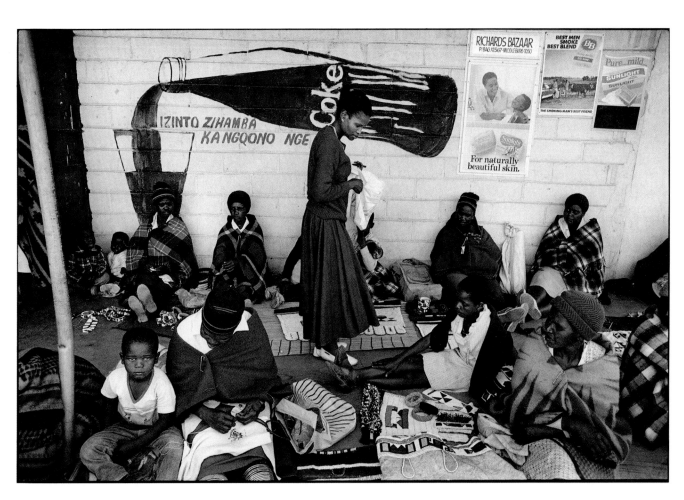

*Dina Mabudafhasi buying
handicrafts, Monsterlus, KwaNdebele*

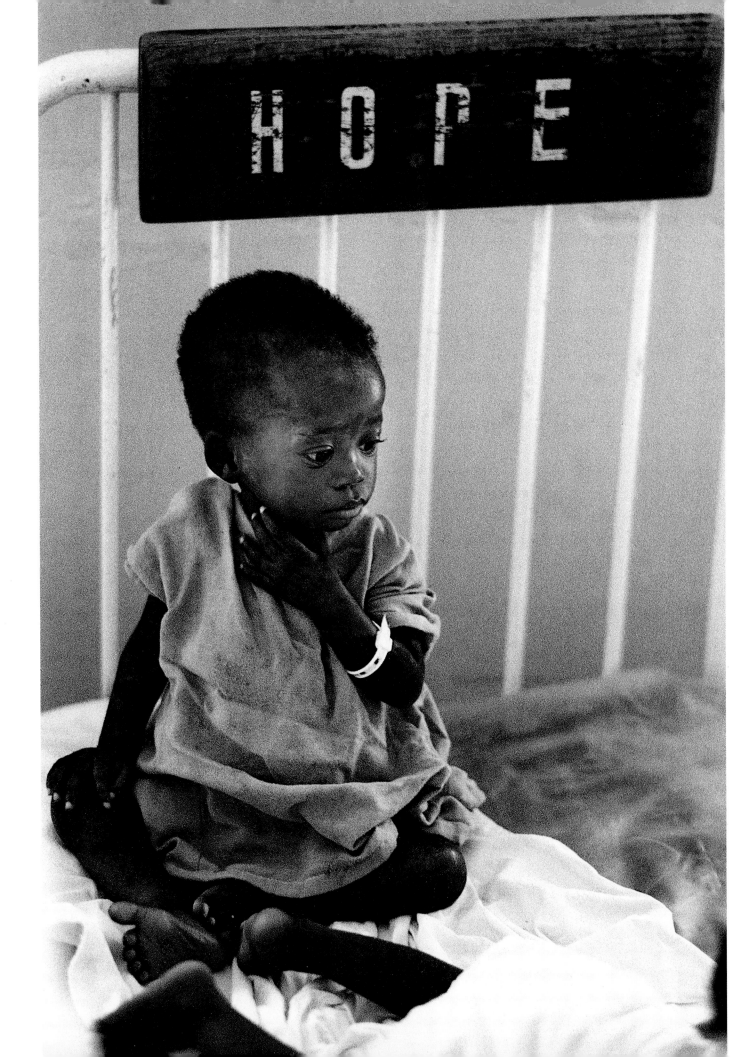

Sekhukhuneland

Sekhukhuneland, the drought-stricken central area of the black homeland of Lebowa, was named after the nineteenth-century Pedi king, Sekhukhune. According to Monica Wilson in the *Oxford History of South Africa*: 'in the 1870s the Pedi chiefdom under Sekhukhune was the most powerful African state in the eastern Transvaal. A counterpart of Moshweshwe's southern Sotho kingdom (present-day Lesotho), it had become a rallying point for the survivors of the northern Sotho chiefdoms that had been disrupted by Mzilikazi and Shoshangane.'

This powerful state on their borders alarmed the Afrikaans burghers of the Lydenburg district, especially as the Pedi raided their cattle herds and refused to acknowledge the sovereignty of the Transvaal Republic. Punitive expeditions were mounted. For some time Sekhukhune successfully defended his territory but he was eventually forced to submit when President Burgers ordered forts built to prevent the Pedi coming down out of the mountains to cultivate their fields.

Sekhukhune's submission was only temporary. As soon as Britain annexed the Transvaal in 1877, he re-asserted his independence. Finally, in 1879, a British force attacked his stronghold and took him prisoner.

I went to Sekhukhuneland for the first time early in 1986, a month after my visit to Monsterlus. Many years before that I had heard of a place far out in the central Transvaal called Jane Furse. I had known it was a mission hospital and that it was very remote, but that was all. It became, for me, one of those legendary places you were never sure existed: far away and difficult to reach.

That first visit did not disillusion me. We took the same road Dina had followed to Monsterlus but, at the junction where the tar ended, we turned left, not right. From there the road north was one such as I had known when I first came to Africa in the 1950s. Most roads in the white areas had long since been tarred and I had thought that 'African' roads no longer existed, but here was one. Full of potholes, dongas, sandbanks, rocks and goats, it led us along ridges and up into rocky hills until, at last, we reached Jane Furse.

Jane Furse turned out to be a simple village of breeze-block houses and general stores scattered along a ridge of granite outcrops stippled with thornbush. A lively debate between various political

◀ *Malnourished child, Jane Furse Hospital, Sekhukhuneland*

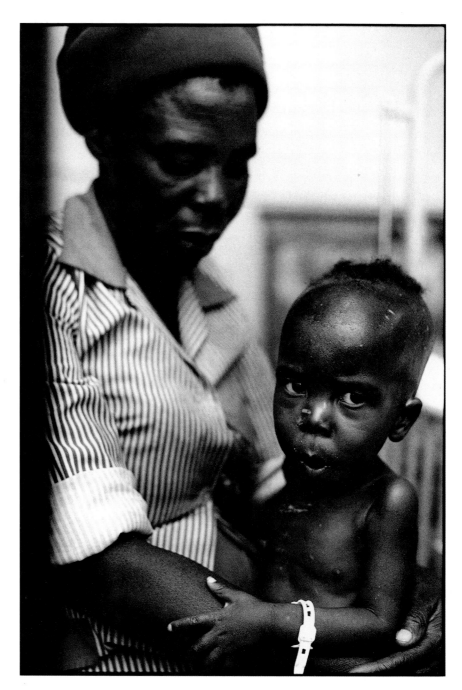

Severely malnourished child, Jane Furse Hospital, Sekhukhuneland

factions was played out in over-painted and repainted graffiti on all available walls. The hospital was a typical African bush hospital. The low, rambling buildings with their covered walkways, set amongst the red and purple of flamboyants and jacarandas, could have been anywhere in central Africa: Lusaka, Dodoma, Maun or Tete.

In the children's ward the resemblance to central Africa was even more marked. People in Johannesburg's northern suburbs were at that time agonising about the Ethiopian famine. But here was Ethiopia, 200 kilometres north-east of Pretoria. Children with the bloated bellies and rusty hair of kwashiorkor. Children with the cracked and scaling skin of pellagra. Tiny wizened children dying of marasmus. All suffering from deficiency diseases caused by poor diet, not in the Ogaden but in the Transvaal, the richest province of

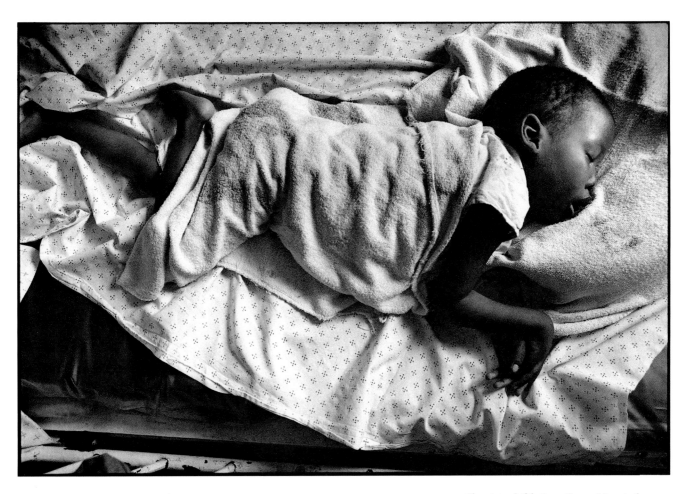

Sleeping child, Jane Furse Hospital,
Sekhukhuneland

the richest country in Africa.

From Jane Furse we went down the eastern slope of the dry hills towards the Steelpoort valley. At the village of Ngoabe we visited the clinic. It was malnutrition day and out in the shade of the buildings a crowd of mothers and children waited for the nurse. Everywhere we saw signs of malnutrition. Some of the children looked plump but it was the false roundness of oedema; their hair showed they were kwashiorkor victims.

In the village the drought was so bad that the stream which normally ran through the main gulley was reduced to a green puddle edged with scum. None of the village boreholes were working. Many of the pumps had broken down and the Lebowa government had not repaired them. People were forced either to dig for water in the stream-bed or to walk several kilometres to the nearest river.

Three months later, in May, I went to Sekhukhuneland again, accompanied by a diplomat and his wife from one of the Pretoria embassies. As we rose into the hills beyond Groblersdal, Ina began to tell them about the history of Sekhukhuneland. 'They have always been in revolt against white encroachment. In the nineteenth century, while Britain was fighting the Zulus in Natal, there was just as big a war going on here against the Boer commandos. Then in the 1950s there was big trouble here. They even brought the army in.

'It's not surprising, really. These hills are barren.' She indicated the rolling uplands dotted with relocation villages. 'The Pedi never tried

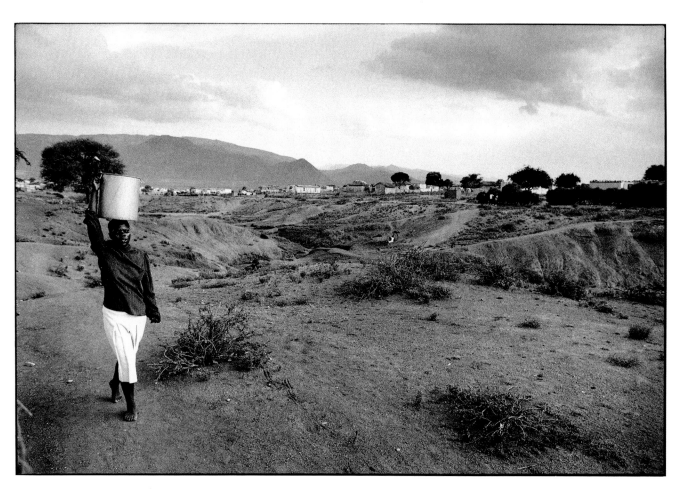

▲ *Carrying water from Steelpoort*
River (under hills in far background),
Ngoabe village, Sekhukhuneland

▶ *Mothers and kwashiorkor children,*
Ngoabe clinic, Sekhukhuneland

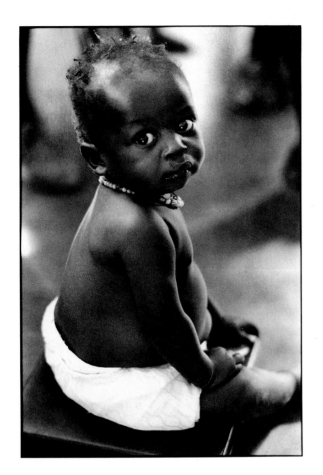

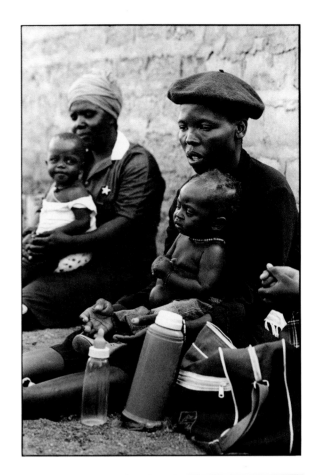

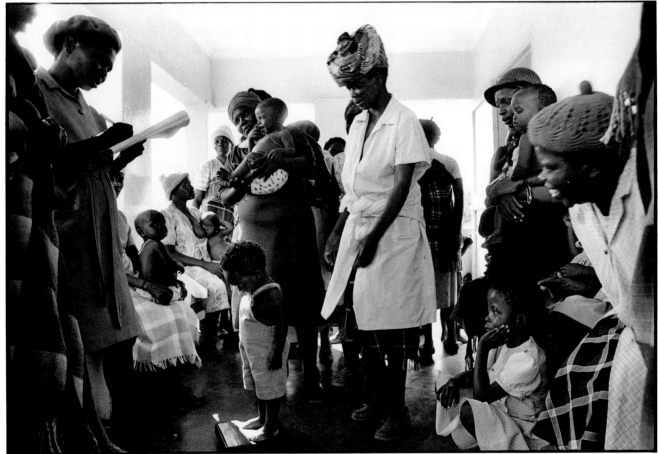

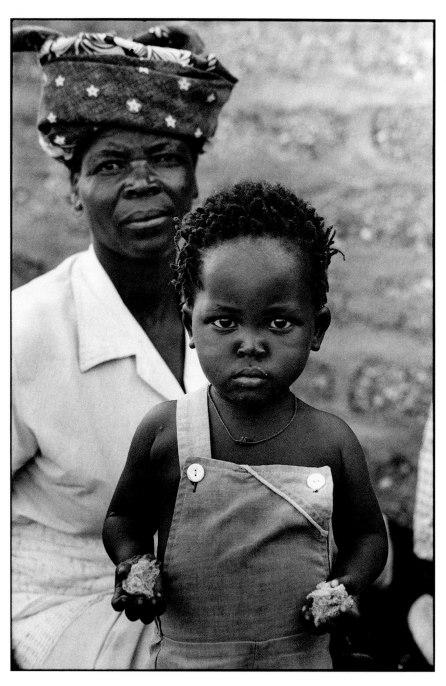

Mother and child, Ngoabe clinic, Sekhukhuneland

to grow crops on them as they are now forced to do. This was the hunting and grazing area of the nation. They grew their crops down in the Steelpoort valley by the river. But that area has now been taken over by white farmers. Hell, they even went and built the Steelpoort post office on top of the royal kraal where the Pedi kings are buried. Can you imagine such insensitivity? No wonder there's always trouble here.

'The present trouble is becoming worse by the day. Already we are having difficulty getting our vehicles into some areas,' she continued. 'In some areas we might even be forced to pull out completely.' I suddenly realised the political knife-edge she, and everyone in Operation Hunger, walk.

At Jane Furse, which had grown a whole new crop of political

24

graffiti since my last visit, Ina and a couple of her assistants dropped off for a conference with the hospital staff. The local fieldman, Johann Rissik, took me and the visitors on to Ngoabe. In the village we went up the hill to a little church, which was the Operation Hunger soup-kitchen. Here we found a group of women cooking soup in a huge iron pot over a thorn-bush fire. Other women were coming in with pails of water on their heads, children on their backs and bits of thorn-bush clutched in their hands. It was another example of Operation Hunger's self-help ethic: even in cases where emergency feeding was necessary, people who wanted soup had to bring the water and firewood needed to make it.

Down at the clinic we saw signs of hope. Women were working to

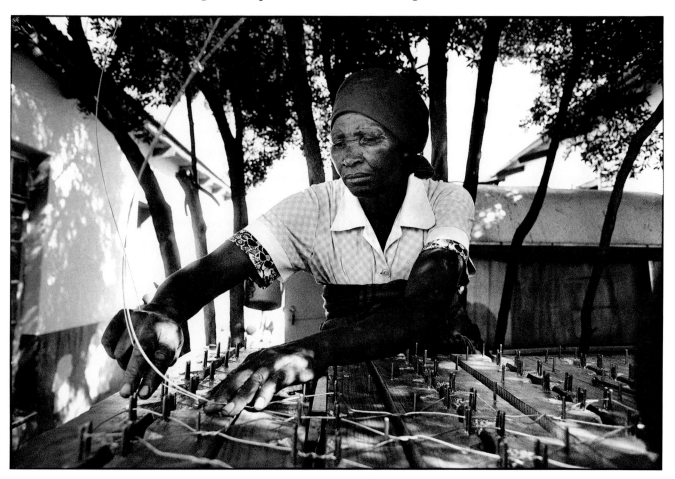

help themselves and their families. On special tables, some were making wire-fencing for sale to help the village income. Other women at sewing-machines were making clothing, also for sale. Outside the clinic, under shade-cloth, was a flourishing vegetable garden which supplemented the general diet of maize-meal. All these, the fence-making tables, the sewing-machines, the shade-cloth and the seed, had been donated through Operation Hunger. But the work, and the will to survive and prosper, came from the people of Ngoabe.

On my next visit to Sekhukhuneland, almost a year later, change had quickened. For a start, the road was tarred most of the way to Jane Furse. Then, when we reached the hospital, Belinda Blaine,

Woman working on wire-fence table, Ngoabe village clinic, Sekhukhuneland

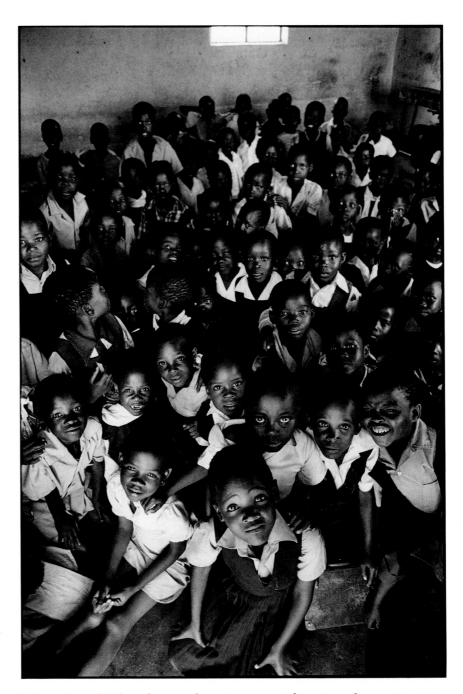

Schoolchildren, Moretsele,
Sekhukhuneland

Johann's co-fieldworker, took us to a magnificent garden project at a nearby village, Moretsele. This was to be an irrigated garden several hectares in extent where the villagers could cultivate individual plots. Already it had a network of irrigation channels running, and some plots were green with cabbage, spinach and beans.

In Moretsele itself we visited the school just at lunch break as the pupils were being given their cups of fortified soup. This was emergency feeding, but with the hope that soon the garden would render it unnecessary.

At Ngoabe, too, there was improvement. When I'd last seen the clinic, the sewing women had been lined up outside in the shade of a wall, working in the open air. Now there was a new breeze-block hut for them and they were inside, out of the weather. Ina told me

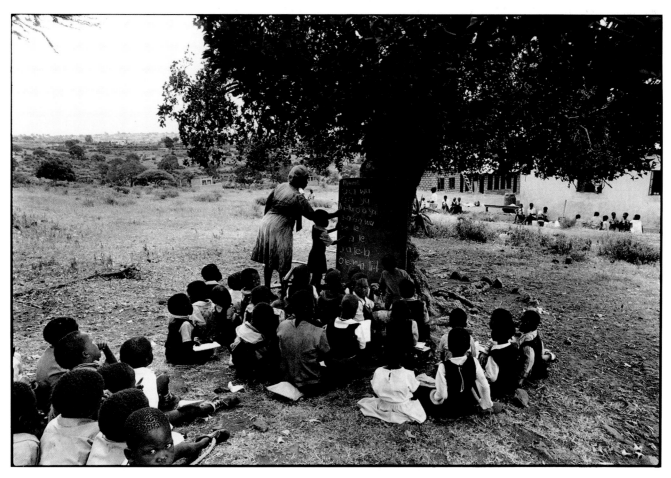

▲ *Outdoor class, Moretsele school, Sekhukhuneland*

◀ *Sewing clothes at Ngoabe clinic, Sekhukhuneland*

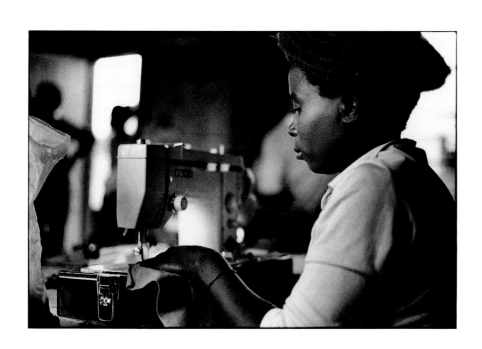

the story of the hut. 'We were wondering what the hell are the sewing women going to do in winter and then I arrived one day to find that they'd got two bags of cement from Johann and they'd made a thousand mud and cement bricks on their own. All we had to do was purchase windows, door-frames and the beams for the roof, plus get a builder in to help them. Basically the women did it themselves. All it cost us was R1 800! You know, when you think of all those palatial R20 000, R30 000, R40 000 buildings so beloved of development agencies! . . .'

Fence-wire production was up. On my first visit we had brought the first fence-making tables to Ngoabe. Now there were tables under shade-cloth all around the clinic, and two women had an enormous roll of fence-wire spread out in the road, checking it for

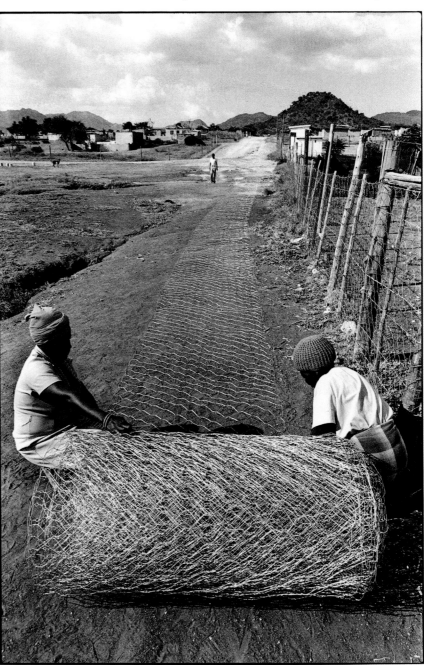

Women checking wire fencing made at Ngoabe clinic, Sekhukhuneland

any flaws.

Not all was so upbeat however. We stayed at Jane Furse overnight and in the morning Johann drove us north to the relocation village of Zanzabela. This was a collection of shacks set out on the bare plain. There were no trees. The ground was granite sand, blinding pink in the harsh sunlight. The people had been moved there in the early 1970s in an official attempt to 'clean up black spots', or, in other words, to move black farming families out of white areas.

Although the yards and streets were scrupulously clean, the despair of the people showed in the lack of improvement of the original huts they had put up thirteen years before. The plots were too small for kitchen gardens and the soil was barren sand. The nearest town for employment was 70 kilometres away. These people knew they had been dumped in the veld merely to remove them from white South Africa.

Later, on yet another visit, I saw even worse places. We went further north, right up to the mountains of the Strydpoortberge. There we ran along the foot of the range on the tar road to Burgersfort and branched off on a gravel road which wound through the bush-stippled foothills to Mathabatha mission.

The whole southern slope of the Strydpoortberge, especially where the Malips River cuts through them, is riddled with small asbestos mines. Since the worldwide asbestos slump they are no longer worked, but the ore-dumps and tailings are still there with

Fetching water at dawn outside Jane Furse Hospital, Sekhukhuneland

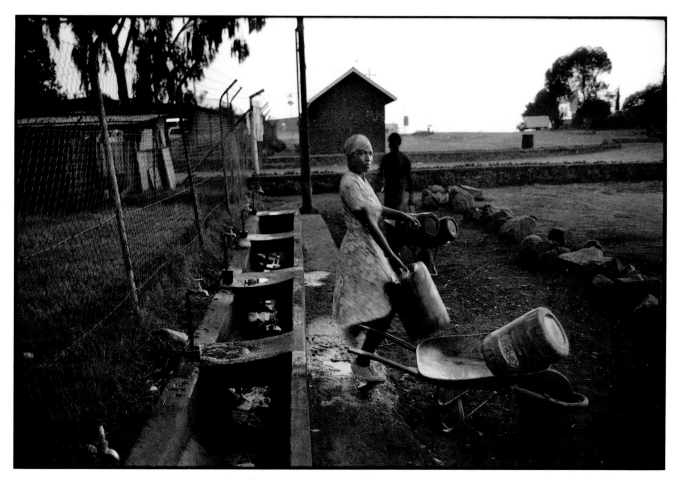

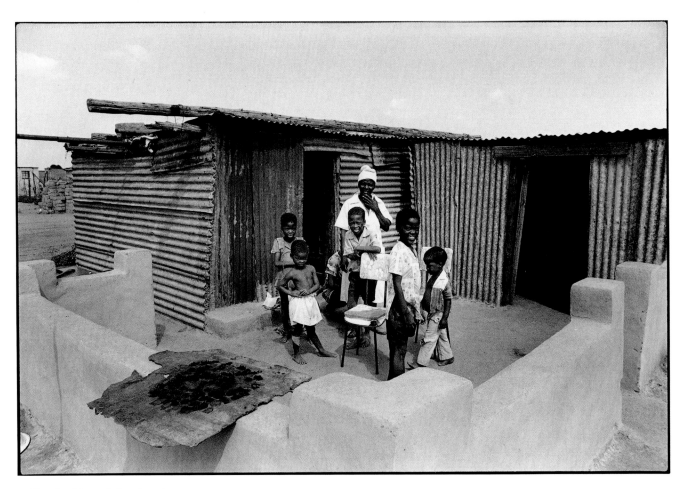

▲ *Family, Zanzabela relocation camp,*
Sekhukhuneland

▶ *Child in Zanzabela relocation camp,*
Sekhukhuneland

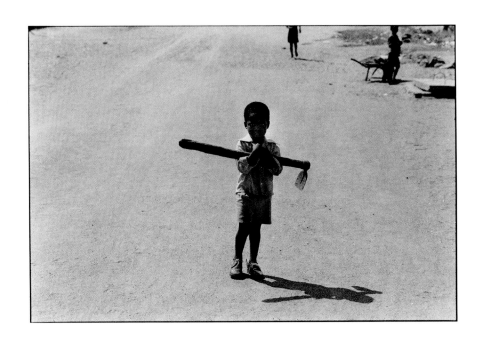

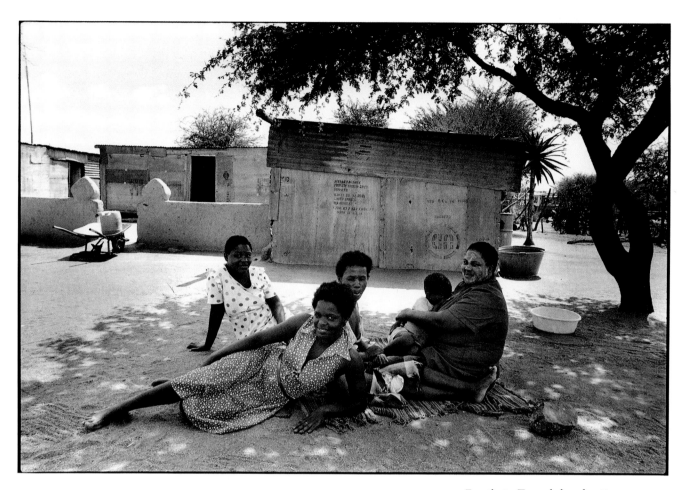

*Family in Zanzabela relocation camp,
Sekhukhuneland*

asbestos fibre exposed to the elements. Every time the wind blows, fibres fill the air and people breathe them. Children play on the dumps and people dig through them looking for useful refuse. The incidence of asbestosis in the district is very high.

In one nearby village we saw a young girl who, with her slim figure and small breasts, looked to be on the verge of puberty. The only thing wrong with her at first sight was that she was too tall, as if she'd shot up too quickly and outgrown her strength. But she wasn't 13, she was 24 and the asbestos fibres she'd inhaled digging around the dumps were killing her. She put out her tongue to show us and I was horrified to see that it was bright blue.

At another squatter area strung along the floor of a narrow valley, everyone seemed to have the disease. The small huts were makeshift affairs of sun-dried brick or corrugated iron standing on bare sand amid stark thorn-trees. There was even one hut constructed of metal off-cuts and old tins hammered flat, the whole stitched together with bailing-wire. In the huts old men and women, and some young men too, lay on beds, too weak to move. These people had been moved in to provide labour for the mines. They had stayed to die.

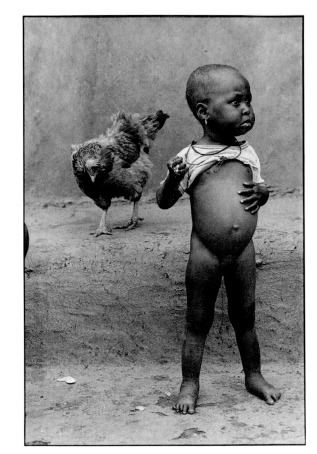

▶ *Kwashiorkor child, Mathabatha,*
northern Lebowa

▶▶ *Woman dying of asbestosis,*
Mathabatha, northern Lebowa

▼ *Family, Mathabatha, northern*
Lebowa

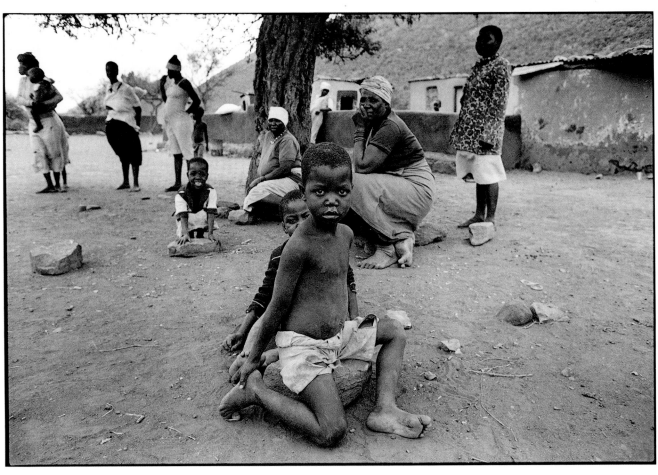

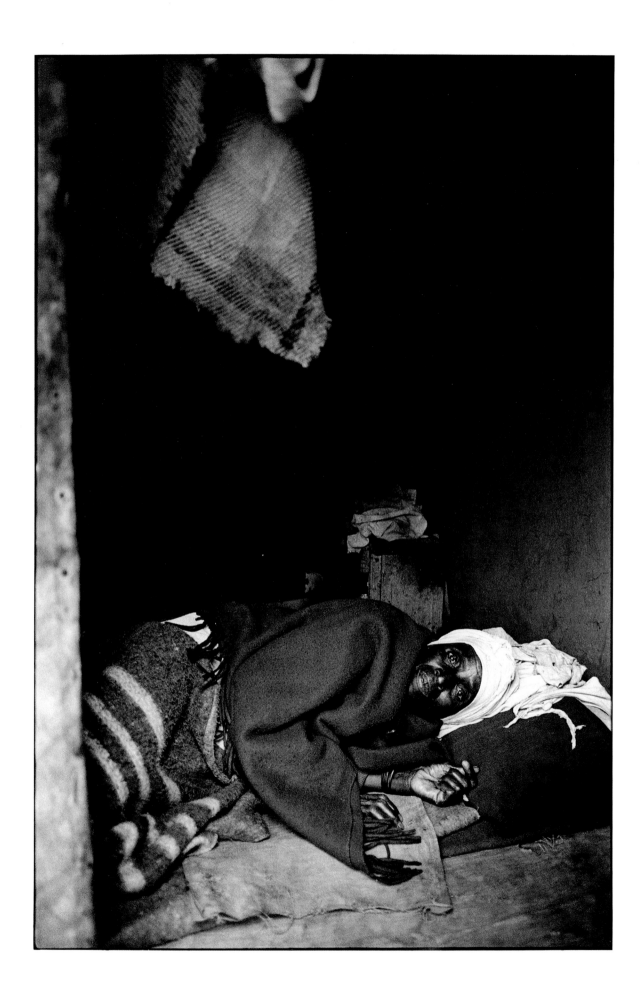

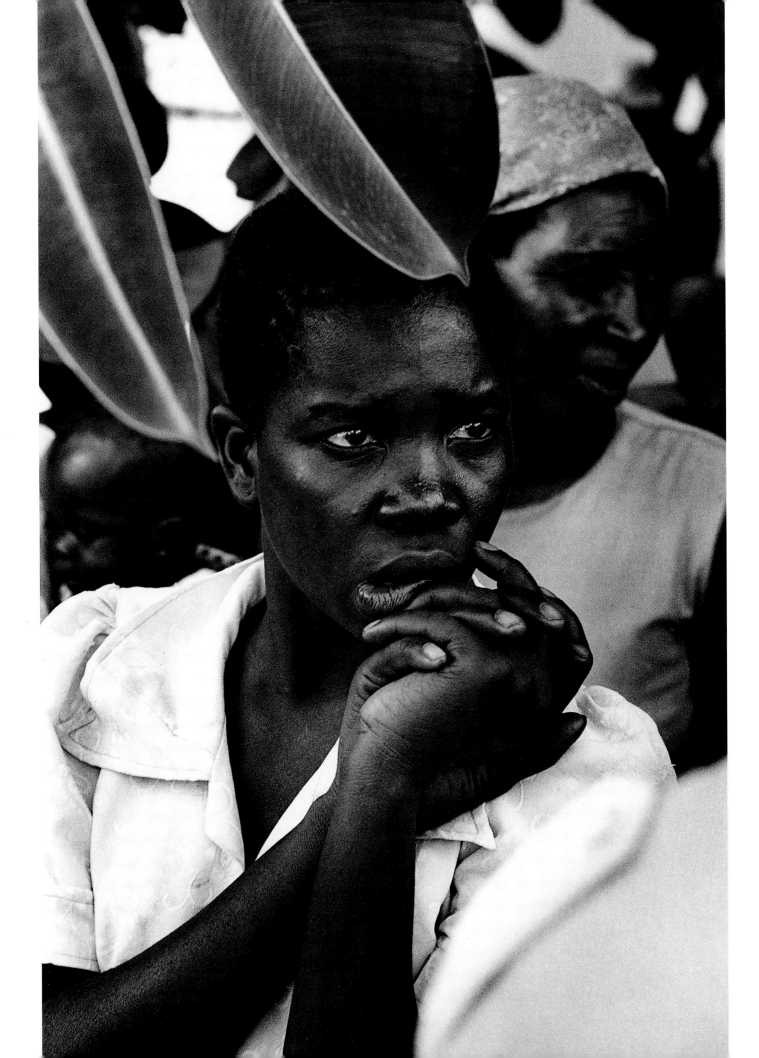

KaNgwane & Gazankulu

The small homeland of KaNgwane lies like a buffer-zone along the Swaziland border from Amsterdam round past Lochiel, Barberton and Louws Creek to the Lebombo Mountains which form the Mozambique border. It contains Swazis who were somehow left out of the original British protectorate which later became the independent Kingdom of Swaziland.

One summer morning we left Johannesburg at Ina's favourite pre-dawn hour of 4 and set off east for KaNgwane through Carolina and Badplaas. In the glare of midday we reached the Shongwe mission hospital. The hot air was thick with dust and the scents of flowering trees. At the hospital we had a meeting with one of the doctors about the refugees who were coming across the border to escape the civil war in Mozambique.

The border, along the crest of the Lebombo Mountains, is defined by an electric fence. Refugees have learned to get through it by prying the wires apart with tree branches, but often some of the party touch the wires and are either burned or killed. The burn cases end up in Shongwe hospital.

To avoid the fence some parties come around its end at Loma-hasha on the Swazi border. There they face the danger of running into a South African army patrol and being shot. To add to the misery there is a strip of land-mines on the Mozambique side of the border laid down to discourage a South African invasion.

Despite the hazards there is a constant stream of people across the border. From the hospital we drove east to Mangweni village. Specially set up to receive the refugees, the village huts were built in Mozambican style with a braided crown of grass at the apex of the thatch and with red and white murals on the walls. The people we met there had just run off into the bush when they heard their village being attacked by Renamo rebels, and had arrived with no possessions.

The next morning we went north beyond White River and Hazyview to the Gazankulu homeland. At Lilydale we came to a cluster of whitewashed buildings inscribed 'Chicago Bar and Lounge' and 'Bottle Store'. In the bottle store we found Sam Nzima and his wife, the proprietors of this oasis. Sam, who is chairman of the Phalalani refugee relief organisation, is a bouncy, optimistic man. He

◀ *Newly arrived Mozambican refugee, Gazankulu*

Mozambican refugees, KaNgwane

has been largely responsible for helping to fit the refugees into Gazankulu society.

Sam told us that there is far less difficulty settling the refugees in Gazankulu than there is settling them in KaNgwane. The KaNgwane people are Swazi while the Mozambique refugees are mostly Tsonga. But Gazankulu people are Tsonga too; there are even relatives on the two sides of the border. The border in that area is completely artificial. It is a line drawn on a map for the convenience of two colonial powers with no regard for the people it divided.

The main obstacle for refugees entering Gazankulu, however, is the 50-kilometre-wide Kruger National Park. Because the park is a major tourist attraction, there is a large, if unobtrusive, army

Refugee children, KaNgwane

presence there. Refugees are always in danger of being caught by patrols. There is also danger from wild animals.

While Sam was talking to us, a small party of people arrived who had just crossed the park. They looked tired and dazed, which was no wonder as they had been walking for four days, two days without water and all four without food. They had been in the fields when their village was attacked and had immediately run into the bush with just what they stood up in. They had not dared to return home.

They said that a troop of Frelimo militia had been guarding the village but, as soon as Renamo attacked, the untrained youths had thrown away their guns in terror and had also run off into the bush. With shooting behind them and the smoke of the burning village in the sky there had been nothing for these people to do but set off west for Gazankulu.

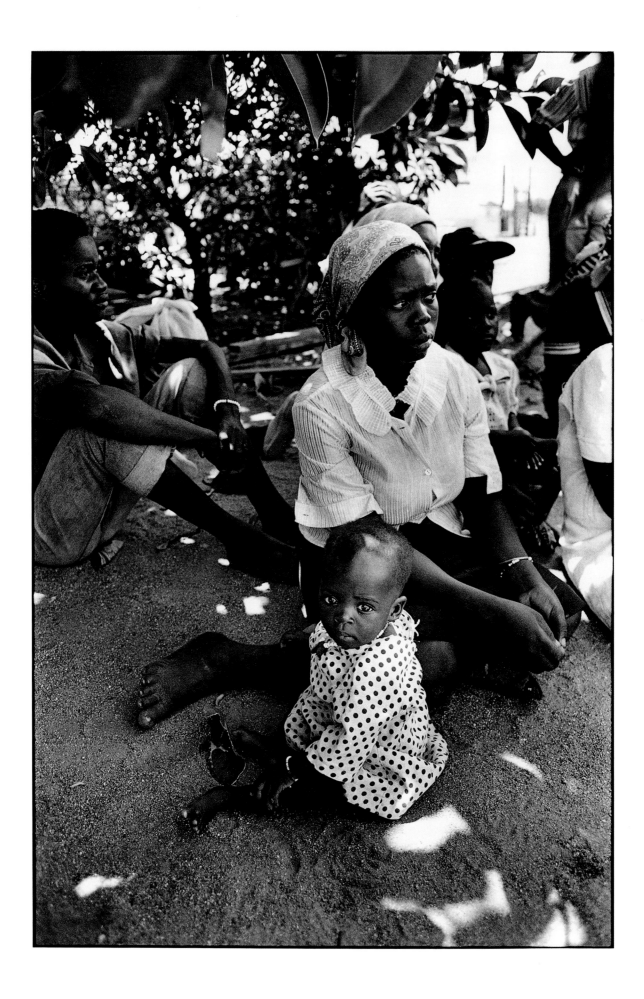

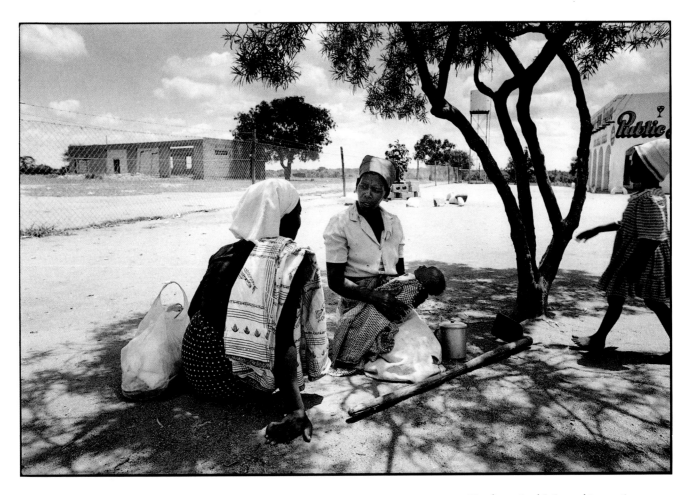

Newly arrived Mozambican refugees,
Gazankulu

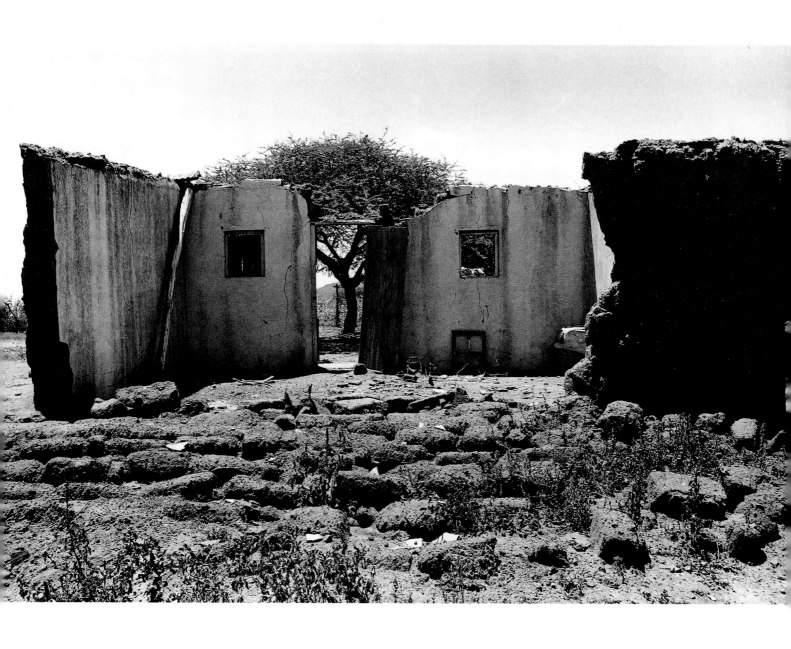

Early one February, in the heat of summer, I went north of Durban into KwaZulu with an Operation Hunger team headed by the Natal regional director, Dot Collins. A morning's drive along the coast road past fields of vivid sugarcane brought us to the Tugela River. There we had to divert inland because the worst floods in living memory, four months before, had washed away the highway bridge at the mouth of the river.

Beyond the Tugela at Gingindlovu, we turned inland towards Eshowe, climbing higher and higher up great ridges. These rolling green hills of Natal are deceptive. They look so rounded and verdant you feel they must be made of thick, loamy soil, but when the road goes through a cutting you can see that the rock is right beneath the surface. The lush greenery is a product of high rainfall, not good topsoil.

This was emphasised when we passed Melmoth and came down into the valley of the White Umfolozi River. Here the country was in the rain-shadow of the coastal hills and it was a semi-desert. Thornbushes and euphorbias dotted the dry sand. We could have been in the Karoo, or even Arizona.

Ulundi, where Cetshwayo's kraal once stood, is a collection of Soweto-style brick boxes sprawled around a large complex of KwaZulu government buildings. That February day we arrived, many of them were still under construction. Their most noteworthy feature was the coils of razor wire along the top of every wall and around every entrance.

Beyond Ulundi, at Mahlambanyati, we were shown hovels of mud and tin inhabited by people who had been flooded out of their homes. These hovels were little caves dug into a mud-bank beside the road, none more than one and a half metres high, with bits of corrugated iron for roofing and doors.

In the valley of the Black Umfolozi River there were many flood-damaged houses in the villages. The victims were living in makeshift huts, or in tents, or crowding in with relatives. At a large mission church a huge crowd of desperate women besieged our Kombi. They had been flooded out of their homes in October but now, at what was supposed to be the height of the rainy season, there had been no rain for two months and the river was dry. They could no longer keep their communal Operation Hunger garden going and their

◀ Flood-ruined house,
Mahlambanyati, KwaZulu

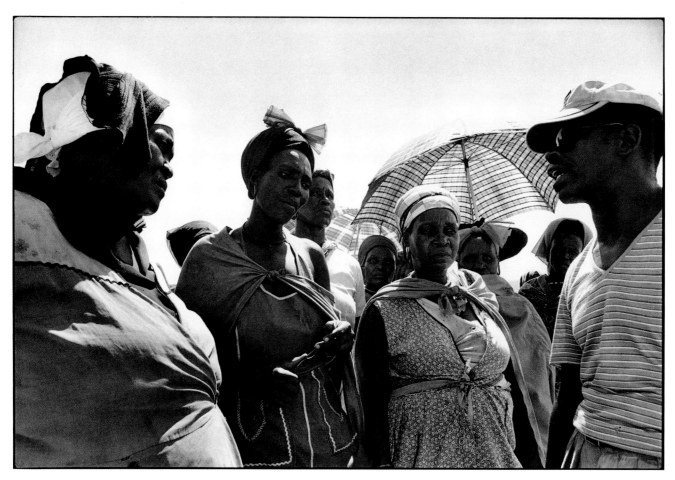

▲ *Flood victims talking to Operation*
Hunger representative,
Mahlambanyati, KwaZulu

▼ *Hovel inhabited by flood victim,*
Mahlambanyati, KwaZulu

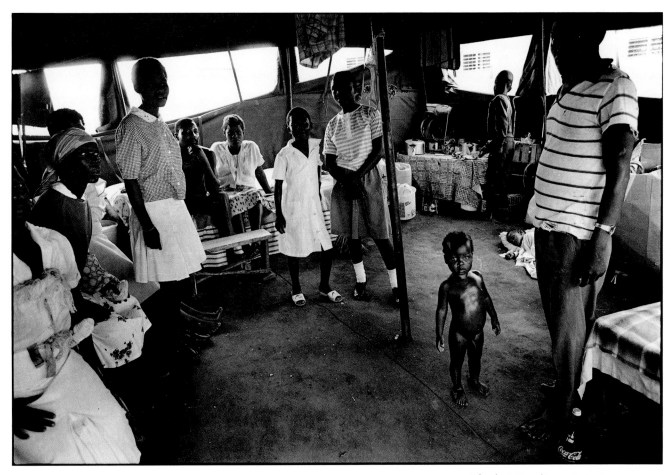

▲ Flood victims living in tents,
Kwandengezi, KwaZulu

▼ Children of flood victims,
Kwandengezi tent town, KwaZulu

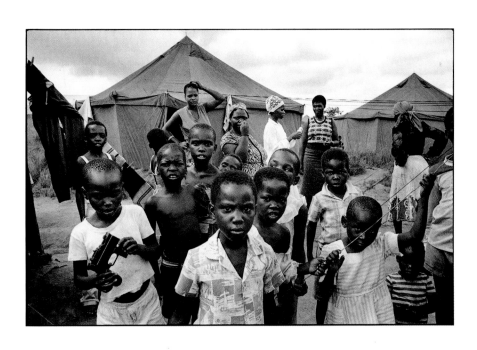

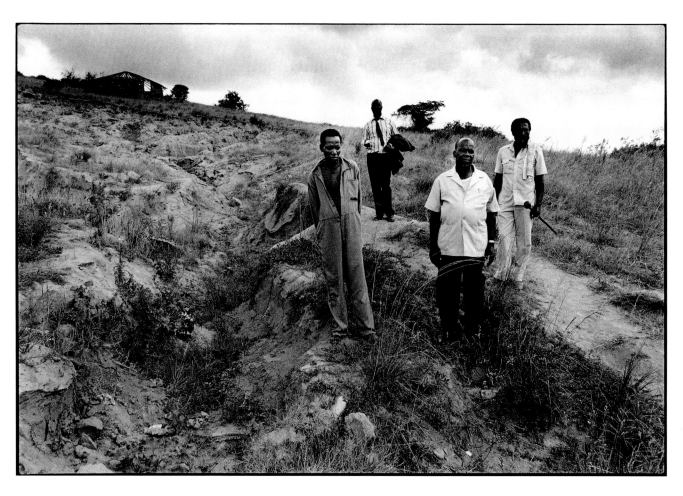

*Village elders and flood-ruined field,
Mangangweni, KwaZulu*

stores of food were running out.

After staying the night at Eshowe we left early and went back down the coast road to Durban, continuing on through the city to the black townships on the south side. All the suburbs of Durban are built on ridges above rivers which cut down through the coastal terrace to form a maze of valleys. A neighbouring suburb just across the valley can be surprisingly difficult to reach because you may have to go kilometres along the valley before you can find a bridge to cross the river. This is as true of the white suburbs as of the black townships.

We drove out along one of these ridges to the township of Kwandengezi. At the entrance to the township we found a huge tent town inhabited by flood refugees. Each tent was a big marquee containing several families. There was no privacy for anyone in the ballroom-sized interior. These people had been living in the tents since the floods and looked set to continue living in them for a long time to come.

By going along ridges and down river valleys we reached Mangangweni, across the river from Kwandengezi. Here we saw some of the flood damage which had cost those tent-dwellers their homes. Surprisingly it wasn't the huts on the river banks which had been destroyed but the huts on the steep hillsides. The rain had been so heavy that sheets of water had poured down the hillsides and swept whole huts away. Huge erosion dongas had formed with the rush of

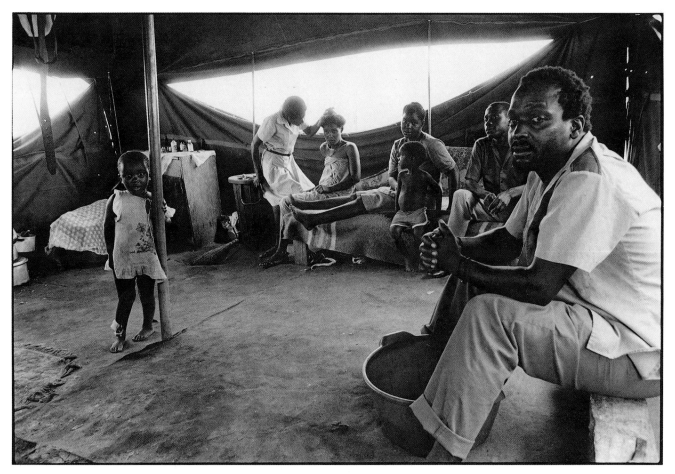

water and had gouged deep into vegetable gardens and maize fields. The loss of cultivation had been as bad as the loss of shelter; the villagers of Mangangweni were too poor to buy much food.

But floods were not the only misery to visit KwaZulu. One of the Operation Hunger fieldworkers with us, who lived nearby, told us that the Maritzburg fighting has spread into the Durban townships. What began as a quarrel between the United Democratic Front and Inkatha has turned into a civil war. She herself was threatened and was forced to move out of her house for safety. 'It's all these young men with guns,' she said. 'There are so many guns in the townships and they all wander round in armed gangs doing what they want.' She, being neither an Inkatha supporter nor a member of the UDF, is one of the many who want to get on with their jobs but find themselves in the middle of a war.

Flood victims living in tents,
Kwandengezi, KwaZulu

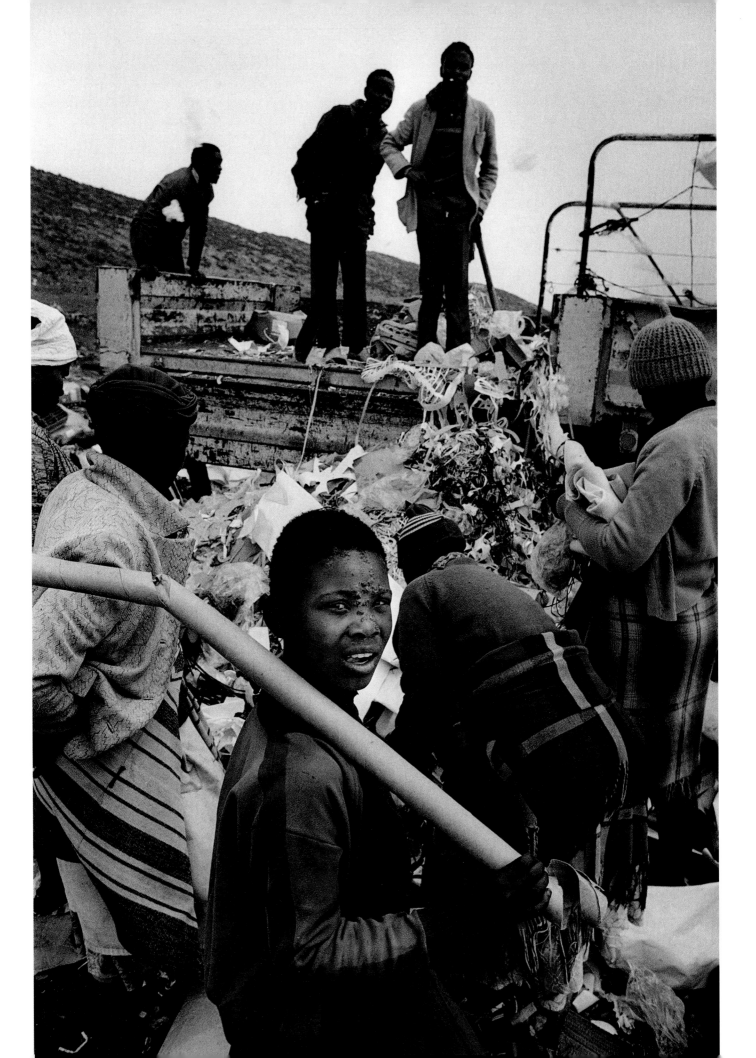

Onverwacht is Afrikaans for 'unexpected', Botshabelo is Sesotho for 'place of refuge'. The settlement called by both these names, though more officially by the second, is the largest relocation camp in the southern hemisphere. Containing an acknowledged 500 000 people (and possibly almost twice that number in fact), it sprawls over low ridges 60 kilometres east of Bloemfontein.

Unexpected it certainly is since it is shown on no map and bursts on the appalled traveller in all its squalor. Its origin goes back to the granting of Bophuthatswana independence on 6 December 1977. The Tswana homeland of Bophuthatswana is probably the most fragmented homeland in South Africa, its pieces being scattered about the Transvaal, Cape and the Orange Free State like a leopard's spots.

The piece of Bophuthatswana directly responsible for the occurrence of Botshabelo was the area around Thaba 'Nchu. After independence the Sotho, Xhosa and some of the Tswana who were living there refused Bophuthatswana citizenship, as was their right under the Status of Bophuthatswana Act of 1977. The local Bophuthatswana authorities saw things differently, however, and began persecuting the 'foreigners'.

Harassment was especially bad in the Kromdraai squatter area. The people there had been endorsed out of Free State town locations or had been evicted from farms. Bophuthatswana police impounded livestock, extorted fictitious taxes and refused children access to local schools. Those who objected were arrested, beaten, even shot.

Qwa Qwa, the south Sotho homeland near Harrismith, felt that the Kromdraai people were their citizens and lodged a complaint with Bophuthatswana. After much discussion the South African Minister of Plural Relations announced, in September 1978, that Bophuthatswana had agreed to cede 25 000 hectares of land in the northern Cape to South Africa in return for 25 000 hectares near Thaba 'Nchu which would be used to accommodate the 60 000 Sotho living nearby. The Chief Minister of Qwa Qwa called this 'a stab in the back'; it was contrary to an earlier agreement whereby Bophuthatswana would cede land in the Cape which would be 'transferred to the Free State to enable the South African government to make additional land available to Qwa Qwa'.

Whatever the rights and wrongs of this, starting in May 1979,

◀Garbage-pickers, Botshabelo garbage dump

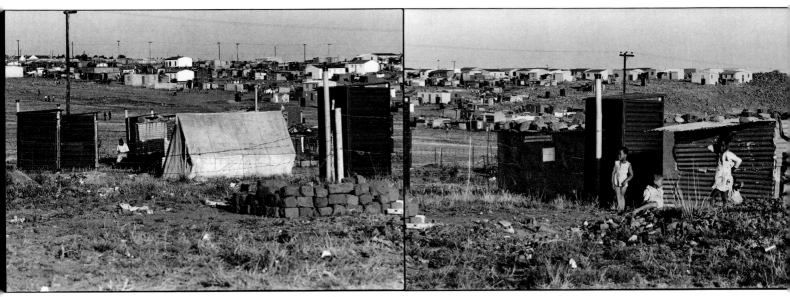

some 38 000 people from Kromdraai were moved to the South African Development Trust farm of Onverwacht, ten kilometres south of Thaba 'Nchu. It was a voluntary move, with many of the people expressing thanks to the South African officials and the Qwa Qwa administration for their relief from persecution. For that reason they called the new settlement 'Botshabelo'.

Conditions for the first arrivals were bleak. Each family was given a 15×30-metre plot, a tent and food for three days. They were told to build themselves some kind of semi-permanent shelter as quickly as possible because the tents would soon be needed for new arrivals. This was in the depths of a Free State winter when icy winds blow across the plains and night temperatures drop below freezing.

The infant mortality rate during the early days of Botshabelo was shocking. In July 1980, during a typhoid epidemic, there were reported to be 258 adult graves and 269 children's graves in the cemetery. This proportion of more child deaths than adult deaths still held true in 1984.

According to an article in the academic journal *Social Dynamics* of 1981, there are five categories of people who end up in relocation camps. The first group consists of those black people owning farms in areas designated white. These so-called black spots were very early seen as a problem by the government, and forcible removal of black farming communities began as early as 1956 in Natal. Often the spur to action was the cupidity of the neighbouring white farmers, voters all, who coveted the land.

The second group consists of inhabitants of black townships in white areas which have been 'disestablished'. Many small or medium-sized towns near homelands have had their black townships closed by law. Black families were moved to relocation camps in the homelands, and people who had jobs in town were expected to commute. At first 122 kilometres, or one and a half hours' travelling time, was considered a reasonable maximum but since then communities have been moved further out. Disestablishment of the locations in many of the small Free State towns swelled the population of Botshabelo considerably.

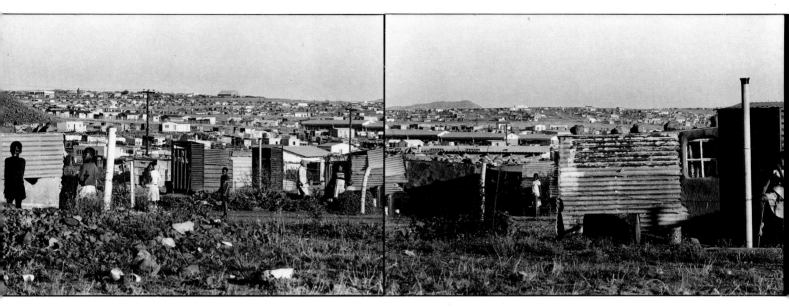

The third group consists of people displaced from townships in white areas by freezes on further house construction and a ban on squatting. This was a method much favoured by bureaucracy in the late 1960s to force people into homelands. The freezing of house construction in Bloemfontein's black townships contributed to the growth of Botshabelo.

The fourth category consists of people evicted or displaced from white farms. According to the Southern Africa Labour and Development Unit, one and a quarter million people were displaced from farms into relocation camps in the period from 1960 to 1980.

The fifth group consists of people deported from white areas under influx control laws, the so-called 'pass laws'. This category no longer applies since the scrapping of influx control but, in its time, it helped to populate relocation camps countrywide.

Onverwacht had not been all that unexpected. The farm itself, and the neighbouring farm Vaalkraal, had been surveyed for development in the late 1960s as a planned black growth point and a labour pool for Bloemfontein. It was easy enough to fit the Kromdraai people into the area, especially when the toilet-building programme got under way with the increase in labour available. These lines of corrugated metal outhouses marching across the veld are the mark of relocation throughout South Africa. At first water was brought round by truck, but now reservoirs have been built in the hills and there is one tap per block in most areas.

I first went to Botshabelo on a cold, wet spring day in mid-October 1986. We went south on the main Bloemfontein road and branched off south of Winburg to wander across the veld on dirt roads until we reached Thaba 'Nchu. There we picked up Mrs Moroka, the daughter-in-law of Dr J. S. Moroka, a president of the ANC in the 1940s, who founded the local hospital. She was a tough bun of a woman with a bright sense of humour. She reminded me of so many other tough, stocky, resolutely cheerful black women. They are the strength which holds the black nation together in these tragic times.

She guided us over the hills to Botshabelo. I was aghast as each

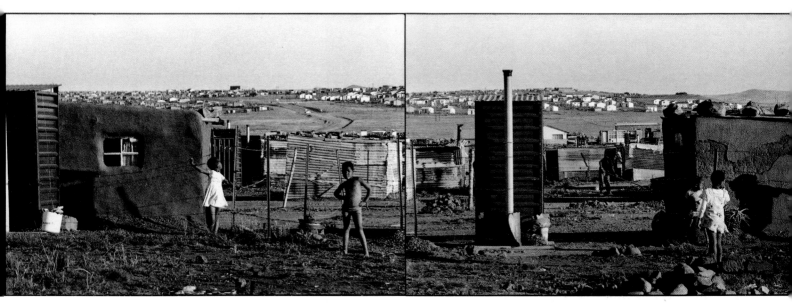

new fold of ground disclosed more and more of it. Tin shanties and sod huts, each with its brown tin outhouse, stretched on and on. Every ridge showed us yet another vista. In the bleak grey light under the low clouds, with rain veils sweeping across it, the township seemed to go on for ever.

Mrs Moroka told us that 80 per cent of the people were unemployed, living on remittances from working relatives or on government pensions which are too low for subsistence. One of their biggest problems is firewood. All wood within any possible distance has long since been cut. People use cow-dung if they can find it, thus denuding the soil of nutrients which would otherwise return to it, or buy paraffin out of what little money they have. Ina said: 'The whole place is an obscenity.'

We went on through this vast sprawl to the last rank of tin toilets. Here, on the furthest edge, we found a tent town. It was a scene beyond anger, a bleakness which cauterised all feeling. The people in these tents once farmed in the Herschel district of the Eastern Cape. In 1971 a referendum was held amongst the blacks of the neighbouring Glen Grey district asking them whether they wanted to remain part of Ciskei or join Transkei. Some 83 per cent voted in favour of Ciskei and, though no referendum was held in the Herschel district, Herschel was assumed to agree.

Then, in March 1975, the Ciskeian legislature, without consulting the inhabitants, decided to trade the two districts to Transkei in return for land between East London and Queenstown. Those in the two districts who wanted to remain Ciskeian would be helped to move and be given land in the new areas although, in fact, the South African government had not yet bought most of the new land for Ciskei. On 1 December 1975, Glen Grey and Herschel were incorporated into Transkei.

The tent town group objected. As their headman told us: 'We are Sotho. We did not want to live under that system in Transkei, nor in Ciskei either. Anyway Matanzima [the then Transkei prime minister] and his officials made life so bad for us we had to leave.

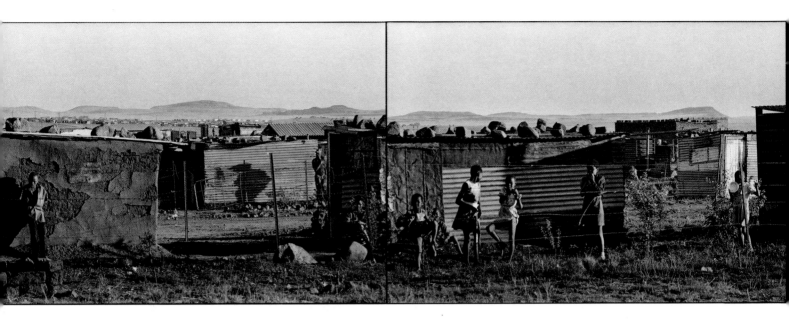

'We went to Zastron and asked the South African government to help us. They told us they could do nothing unless we went to Qwa Qwa, so we did. There Dr Koornhof himself promised us a farm near Harrismith. We waited in Qwa Qwa more than three years but when the farm was bought it was given to Mopeli [the chief minister of Qwa Qwa], not us.

'We complained to Pretoria but they said they gave the farm to Mopeli and it was our problem with him if he will not give us the farm. Then Mopeli told us to go away to Onverwacht.

'On 3 July this year [1986] they came with GG [government] trucks and took us to Onverwacht. They gave us these tents and food for three days. We are still living in these tents. Last winter we froze but we will not build shacks because then they will think we have agreed to stay here.

'No, the problem is Pretoria's, not ours. They gave our land in Herschel to Matanzima, they didn't ask us. Then they promised us the Harrismith farm, we even have the minutes in writing, but they gave it to their man Mopeli, not us.

'Now they tell us this place Onverwacht will be incorporated in Qwa Qwa. If it is, we will pack and leave. We cannot live in these homelands. We have tried twice already.

'All we want is some land for ploughing and grazing. All our animals are still in Herschel. There are 28 000 of our people in Herschel. They do not want to be under Transkei. We all want to be part of South Africa.'

[On 2 March 1990, the Appeal Court upheld a Supreme Court decision against the incorporation of Botshabelo into Qwa Qwa. At the time of writing, Botshabelo remains South African.]

The following winter I visited Botshabelo again. It was mid-June and under a cloudless winter sky the air was icy. It was also moving. A freezing gale was sweeping up from the south over the Free State plains, raising vast clouds of dust. Everywhere the inhabitants were out, standing wrapped in blankets against the northern, sunlit walls

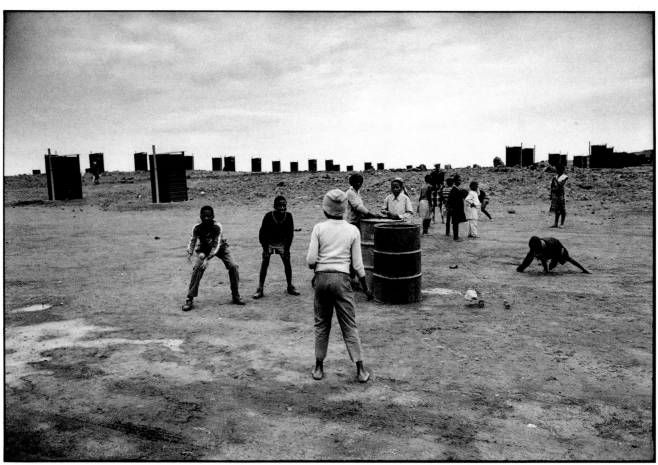

*Children playing near tent town,
Botshabelo*

of their huts, using the buildings to shelter themselves from the wind, absorbing every possible photon of the sun's warmth. For myself, I found that I could only manage ten minutes at a time out in that gale before I had to retreat to the car, numbed and dizzy.

At the tent town the Herschel group were enduring their second winter in tents. The tents whipped and billowed in the wind, and people darted out to fetch water or to visit the tin toilets before clambering back into shelter and tying up the flaps. Ina and I stood talking to the headman and his wife, shivering inside our sheepskin jackets. The two Herschel refugees held themselves rigid against the cold, clad only in old, darned jerseys.

Fifteen months later I visited Botshabelo for a third time. The Herschel group were still there, having by then spent over two years in tents. Many of the original tents, however, had not survived. The storms of October 1987 had destroyed many of the big army tents and these had been replaced with smaller bell-tents. The group was still as determined as ever to get farming land in South Africa, despite broken promises and the prohibition on black farming outside the homelands contained in the 1913 Land Act.

On one visit to the Herschel group we had been accompanied by an American observer. After we had listened to their headman tell us of the group's problems, she had turned to me and said: 'No matter who takes over the government of this country, ANC or whoever, they'll have to sort this mess out and I don't see how they'll do it.' Sadly, I had to agree with her.

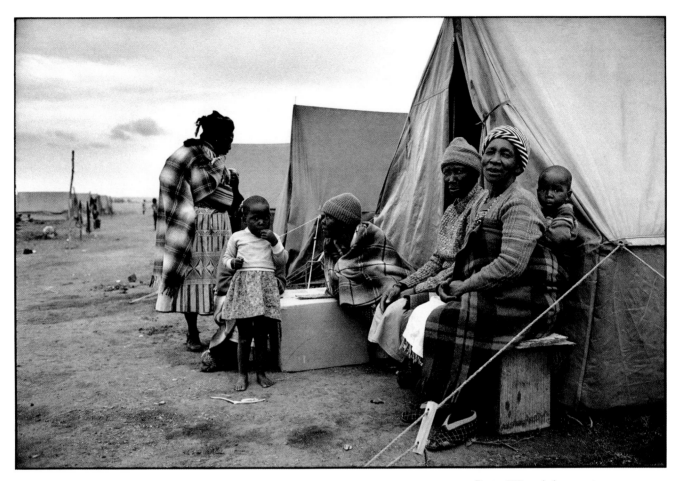

▲ *Part of Herschel group in tent town, Botshabelo*

▼ *Herschel group children, tent town, Botshabelo*

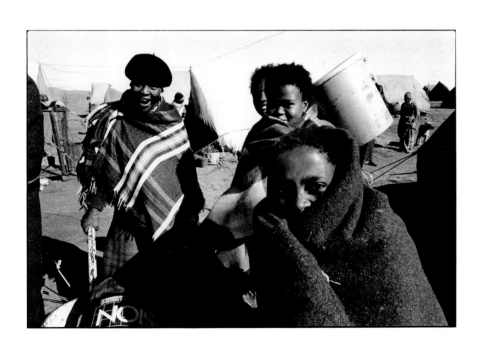

▶ *Herschel group child, tent town,*
Botshabelo

▼ *Ina Perlman and headman of*
Herschel group, tent town, Botshabelo

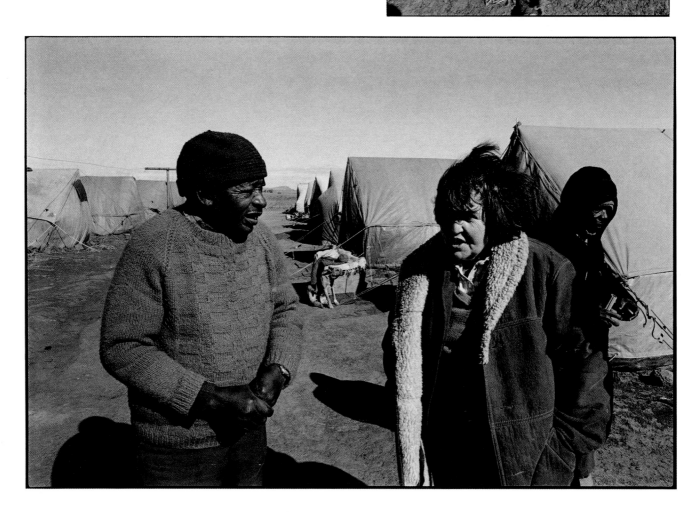

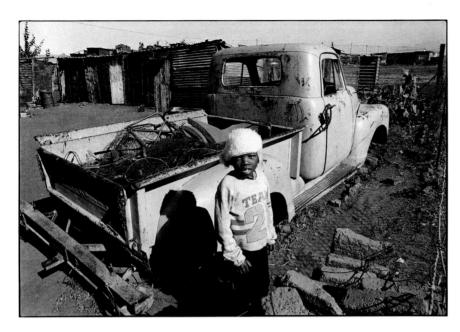

◀ *Child in front of wrecked truck, Botshabelo*

▼ *Wrecked car, Botshabelo*

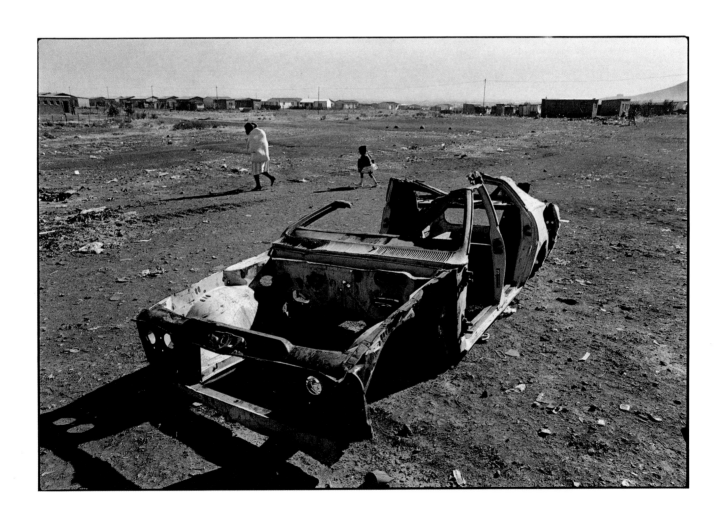

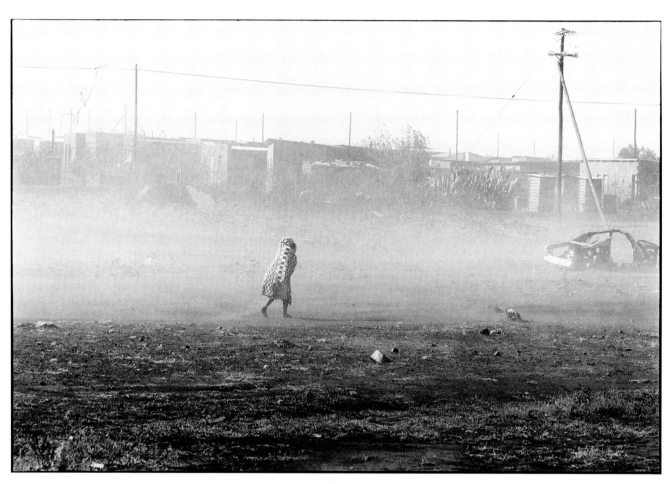

Winter dust storm, Botshabelo

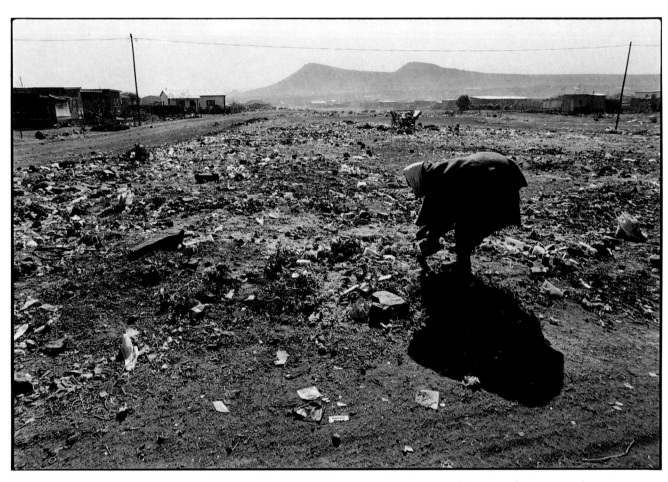

Woman picking over garbage,
Botshabelo

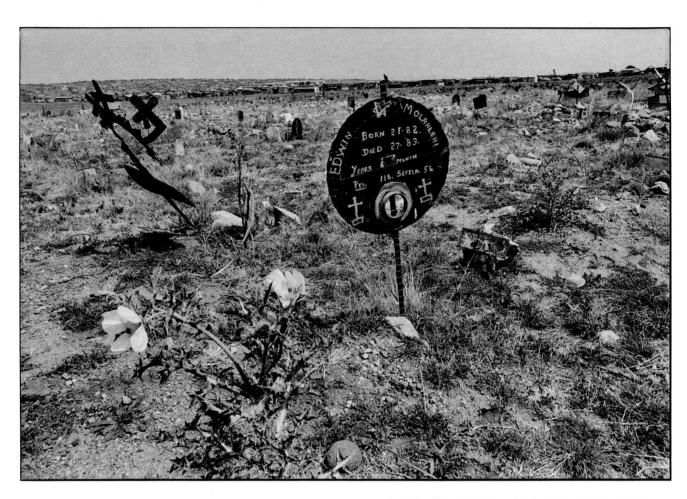

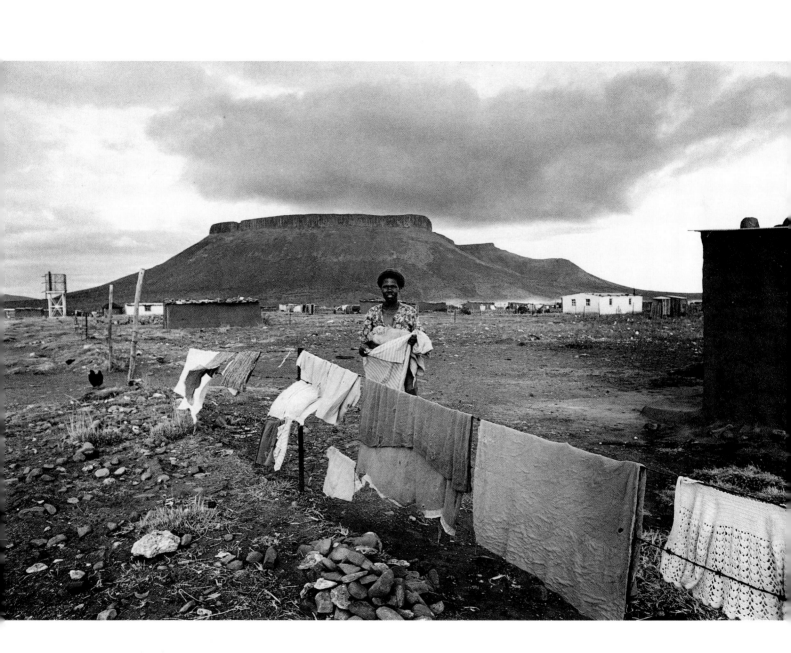

The first homeland to be granted independence (in that wonderfully paternalistic phrase) was Transkei, on 26 October 1976. Even before that, in 1975, after the Ciskei legislative assembly agreed to cede the Herschel and Glen Grey districts to Transkei, some 5 000 people had objected to becoming Transkei citizens. Ciskei and the South African government had then moved those Glen Grey and Herschel people to supposedly temporary relocation camps near Whittlesea and Queenstown.

◀ Woman hanging out her washing, Tentergate relocation camp, Ciskei

With the coming of Transkeian independence a flood of people began to follow them. By March 1977 it was reported in Hansard that 12 600 had moved into the camps, although unofficial figures were nearer 32 000. This was far more than had been expected or provided for. Health hazards grew. In a couple of camps it was reported that there were no latrines at all. Children were especially vulnerable and began dying of gastro-enteritis and diarrhoea.

Early in 1977 the woman doctor in charge of the clinic at Thornhill camp got fed up with the unfulfilled promises of Ciskei's chief minister. Vaccine and a mobile X-ray unit were promised her time and again while each day five children died of tuberculosis. Finally, despairing of ever getting aid, she went to the press. This resulted in her dismissal, but suddenly Dr Barbara Seidler and Thornhill were news.

I was present at one of her press interviews. The reporter asked her how South African poverty compared with poverty in Brazil where Dr Seidler was born. 'Oh, these things are not comparable,' she replied. 'Objectively people here are better off because even the poorest blacks here have more money than most people in Amazonas. But it's really worse here because you deny them human dignity. Poverty really means little. Human dignity means a great deal.' Then she added: 'One day people will talk about places like Dimbaza and Thornhill the way they now talk about Dachau and Auschwitz.'

After Dr Seidler's dismissal, steps were taken to improve the situation. Latrines were dug, water reticulation was installed, clinics were built and staffed. People's health improved but the 'temporary' relocation camps remained. They remain to this day: Sada, Thornhill, Oxton, Yonda, Katberg, Kamastone, Peddie extension, Crossroads, Glenmore, Potsdam, Tentergate, Emadakeni, Frankfort.

The Ciskei has almost no industry and cannot absorb the tens of thousands who now inhabit these camps, swelled, not only by Transkei refugees, but also by people evicted from white farms and the squatter townships of Cape Town.

In 1987 Dr Frances D'Souza, of the University of Oxford, offered to do a survey on rural economic vulnerability in South Africa for Operation Hunger. It was a pilot survey to find out the relationship between poverty and malnutrition in children and to indicate guidelines for Operation Hunger to use in pinpointing communities in danger of severe malnutrition.

In June of that year I went down to King Williams Town in the Eastern Cape to join Dr D'Souza on the part of her survey which dealt with the Ciskei relocation camps. At the hotel in King Williams Town I met her and Operation Hunger fieldworkers Mpho Mashinini, Zwayi Pongoma, Tumi Mashinini and Florida Metele. As soon as I had booked in and dropped my bags we set off west into the Ciskei.

A few kilometres from King we spotted a squatter village straggling across a hillside: a collection of mud huts, wooden shacks and corrugated-iron lean-to's. Every conceivable type of building material had been used, including flattened kerosene drums. One hut even had a wall which incorporated the hammered-out bonnet of a Peugeot car. The headman told us the settlement was called Nyanyazwedi.

Frances was working on a 5 per cent sample. Since Nyanyazwedi was a small community this meant about a dozen family interviews. We divided into two teams and began.

I went with Mpho and Zwayi in the Kombi. We drove to the far end of the camp and started at the first hut there. Mpho greeted the people, explained about the survey, asked if the family would co-operate and then, when they agreed, began a long list of questions.

He asked about the numbers and ages of grandparents, children and grandchildren, and how many were away working. He asked

Pensioner, Xukwana village, Ciskei

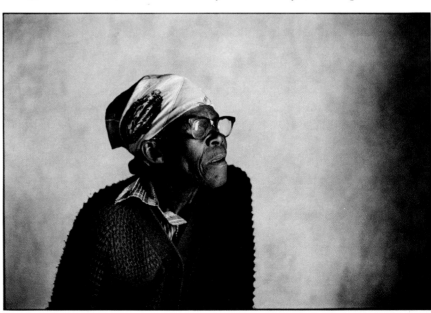

about the nearest water and what arrangements there were for sanitation. He asked if the family had any assets in the form of land, livestock or vehicles. He asked about the local cost of maize, vegetables, meat, milk, tea and sugar. He asked about the family's income and whether those members away at work sent remittances, whether anyone drew wages for local work and whether any of the older people drew pensions. He asked whether the last child was born alive, how the family got food if there was no money and, finally, what worried them most. All the smaller children were measured, weighed and checked for oedema of the lower legs, an indication of kwashiorkor.

From that first family we worked back towards Frances's team, counting our way past twenty huts to the next one to be surveyed.

Child, Nyanyazwedi relocation camp, Ciskei

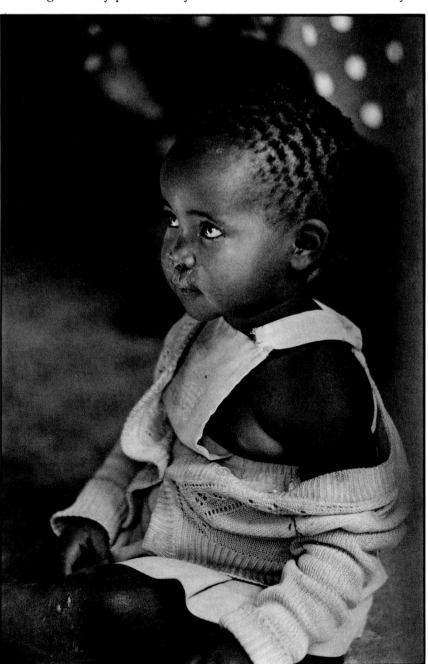

Everyone was amazingly polite and tolerant of us. Families seemed to consist of women, children and old people. Most of the young and middle-aged men were away working.

After a few hours we met the other team in the centre of the village and went on west along the Fort Beaufort road. At Middledrift, a small settlement dominated by a large prison surrounded by razor-wire, we stopped for lunch and directions to the next village on Frances's list, Xukwana.

This was an older, more established village consisting in large part of 'traditional' round thatched huts strung along the grassy crest of a hill. Frances had wanted to include it in the survey precisely because, being long-established, with agricultural land available, it provided a contrast with the more recent relocation camps.

Certainly people in Xukwana seemed better off than those in Nyanyazwedi, though the same proportion of women, children and old people prevailed. This improvement, Frances thought, was due to the longer period of settlement which had given time for people to find employment and establish agricultural plots.

The next morning we left our hotel in King and set off north along the Queenstown road. As we drove, Frances explained some of her criteria of malnutrition to me. If a child which has grown up on a good diet is suddenly deprived of adequate food it will start to use its stored reserve of fat and so lose weight. If the poor diet continues, the child's weight for its height will become lower than would be expected and it will be said to be 'wasted'. If a child suffers long periods of inadequate food from an early age it will not grow as much as expected and its height will be lower than normal for its age. Such a child is said to be 'stunted'. Wasting is an indication of current acute malnutrition while stunting is an indication of chronic, long-standing lack of food.

Frances said that, while there is a proven link between acute malnutrition and child mortality, the link between chronic mal-nutrition and mortality is less clear. Short children may survive as well as tall children, but excessively thin children are always at risk from disease because they have no reserves. Thus wasting is a reliable indicator of risk while stunting is not.

'The problem is', continued Frances, 'that oedema resulting from kwashiorkor increases the child's weight because of the water retained in the tissues. So the weight-for-age ratio can appear healthy when the child is really suffering severe malnutrition. That's why I insist we test each child for oedema.' However, the real indicator of risk, she added, is the presence of a deficiency disease such as kwashiorkor, pellagra or marasmus.

At Cathcart we turned west off the main road towards Thornhill. It was a bleak morning with occasional flurries of rain. The mountain tops were lost in cloud and there were patches of snow on the upper slopes. Everything was grey or ochre, as bleak as midwinter in Scotland.

We reached Thornhill clinic at noon, a farmhouse expanded into a makeshift hospital. Over tea we met the young doctor in charge. He

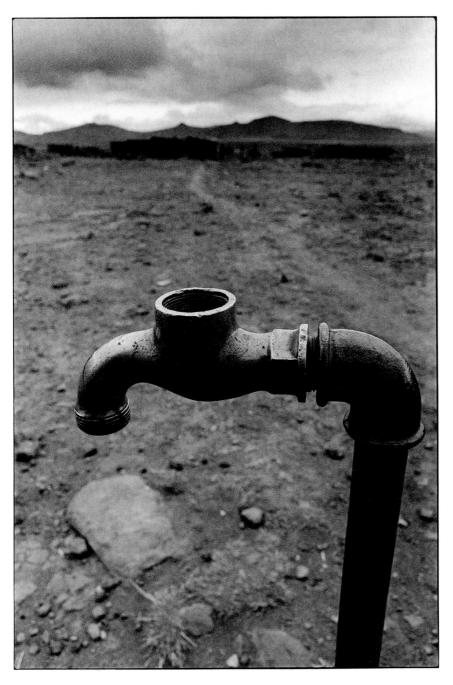

Tentergate relocation camp, Ciskei

told us which settlements we should see in the district and gave us three district nurses to guide us around. He said that, while all the settlements were relocation camps, in some of them people had been moved two or even three times from one camp to another. He said he saw a direct relationship between the number of times families were moved and the child mortality rate. The more relocations, the higher the number of children's deaths.

An hour's drive from Thornhill we reached Tentergate relocation camp. This time I went with Frances, Florida and Tumi walking from house to house, while Mpho and Zwayi went off to the other end of the settlement with the Kombi.

Tentergate is a large settlement. The dark brown mud huts scattered about the barren ground were stark under the sombre roof

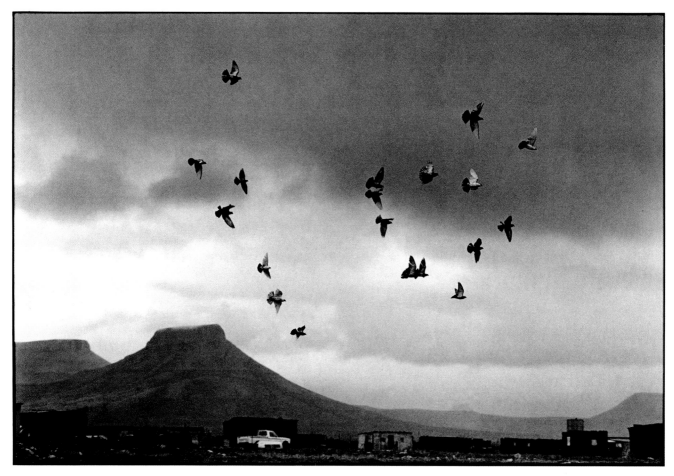

▲ *Tentergate relocation camp, Ciskei*

▶ *Magephula family, Tentergate relocation camp, Ciskei*

▼ *Dr Frances D'Souza testing child for oedema, Tentergate relocation camp, Ciskei*

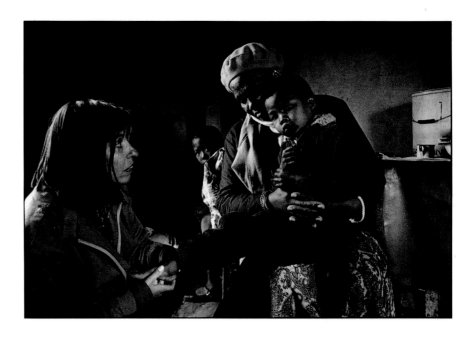

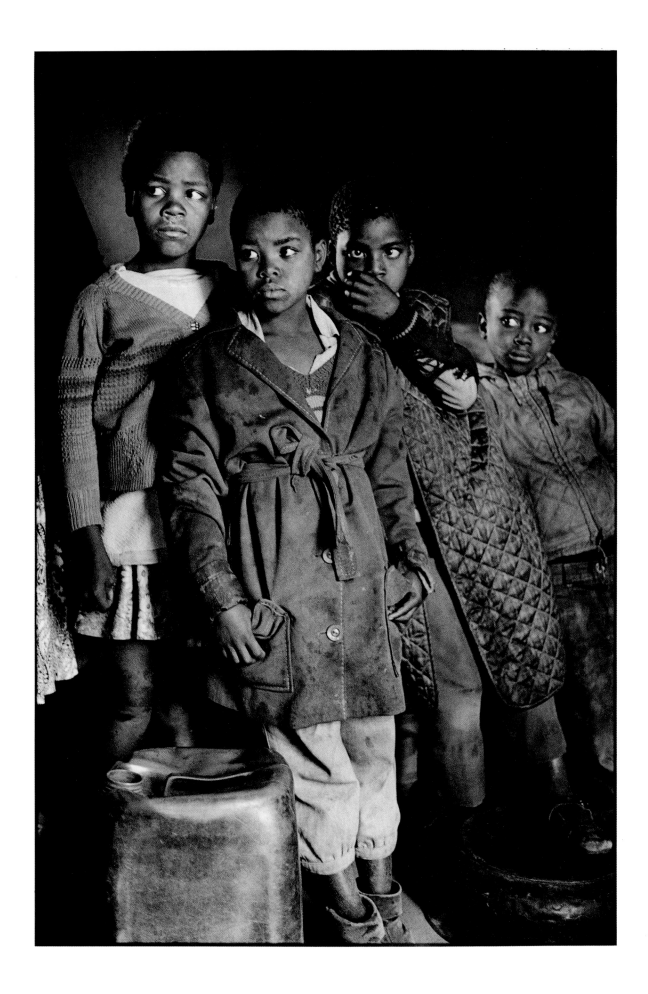

of cloud. We met desperate poverty in the very first hut we visited. In a small shack made of flattened kerosene cans and corrugated-iron sheets, huddled under blankets on a bed, was a young woman. Scarcely beyond girlhood herself, she had two young children. Where was her husband? Away working in Cape Town. Did he send her money? Sometimes, but she feared he had another woman in Cape Town because she heard from him so rarely. Did she have relatives nearby? No, she was alone in Tentergate. Had she money? No. What was she going to do? Shivering against the cold, she pulled the blankets round herself and shook her head. She didn't know. Maybe her husband would send money or come back.

We walked on through Tentergate, moving diagonally across the rows of huts. The wind was icy, water lay in the ruts of the roads, there wasn't a tree, a bush or even a patch of maize growing anywhere on the bare earth. In the huts we visited, people crouched in swathes of blankets or pressed close around smoky fires. Old women lay wheezing in bed.

Yet often, in the meanest hut, there was good furniture standing against the bare earth walls and the interiors were swept clean. One woman was busy re-plastering her walls with fresh mud. It all told a story of happier, more prosperous times past, as well as of a determination to survive the present.

With a watery sun low between black clouds in the west, its pale light merely accentuating the cold, we came to a complex of two huts facing each other across a *lapa* or courtyard. In each hut was a widow, first and second wives of the same man. The first wife was a severe old matriarch, alone in her hut, who refused to talk to us. The second wife was younger and was surrounded by children. The smoky fire was raising the temperature of her hut barely above that outside, making the air unbreathable in the process.

She told us that, as a second wife, she got no pension. The first wife received a pension but refused to share it. No doubt there was considerable jealousy about the fact that the first wife had been unable to have children. Two of the second wife's daughters worked on a distant farm. They were not paid cash wages but were given bags of maize-meal which they sent home from time to time. That was what kept the whole family alive.

What impressed me, as it had done earlier in Sekhukhuneland and Botshabelo, was the strength of these women. A surprisingly large number of whites still refer to their female black servant as 'my girl', even if she is a grandmother. At the same time, male chauvinism is strong and traditional in black society. Despised by whites for being black, and patronised by black men for being female, black women are on the lowest rung of the pecking order in South African society. Yet their strength, courage and natural dignity are awesome. Mothers of the Nation every one, they do their best to give their children love, comfort and some sense of home even in the impossible conditions of a relocation camp.

We went on with the sampling until dark. It was a cold sunset amid wild black clouds. We couldn't see any sign of the Kombi as we

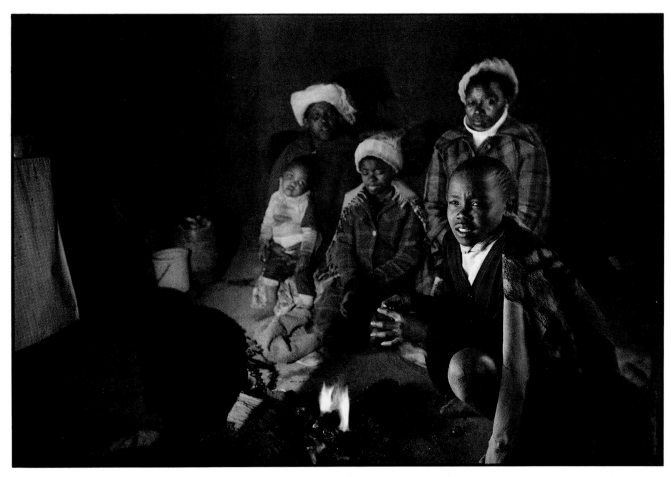

walked back to the general store in the twilight. The store was closed, so we stood outside in the chill wind as night fell. Soon it was completely dark for there was no electricity or street lighting in Tentergate. Eventually we saw headlights approaching and Mpho arrived. We gasped with relief as we entered the warm car, but what about the people we had left behind in those dark shacks?

We spent the night in a hotel in Queenstown and set off early the

▲ *Ngqa family, Tentergate relocation camp, Ciskei*

▼ *Fetching water at dusk, Tentergate relocation camp, Ciskei*

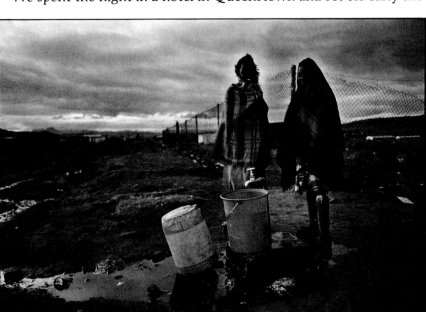

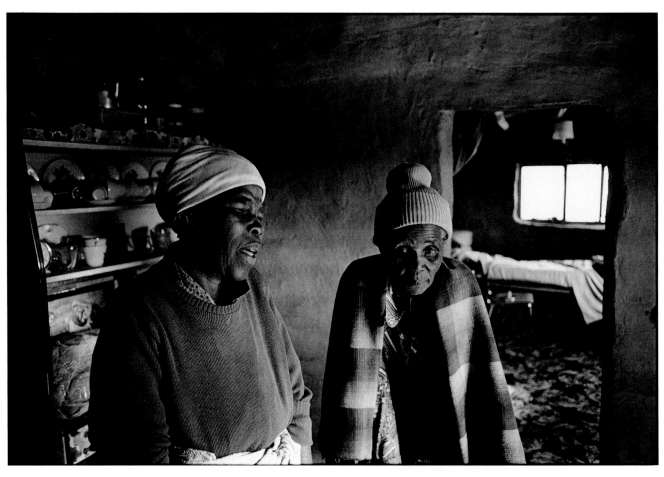

▲ *Mrs Magega and her mother,*
Oxton relocation camp, Ciskei

▶ *Tumi Mashinini measuring child,*
Oxton relocation camp, Ciskei

next day to visit Oxton relocation camp. It was a bright, icy morning. The distant mountains, so clear you could see the rocks on their crests from ten kilometres, were deceptively beautiful. But it was the false beauty that Milton in *Paradise Lost* ascribes to Lucifer the fallen angel: a beauty masking hideous reality. In that diamond-hard light which graced the mountains, the foreground huddle of tin shacks and mud huts that was Oxton was surreal in the intensity of its squalor.

We went up a hill to the little clinic, where two roads met, and found a couple of nurses who were prepared to show us around. Again we split into two teams and began sampling families.

Oxton is an old relocation camp, one of the first. Some of the

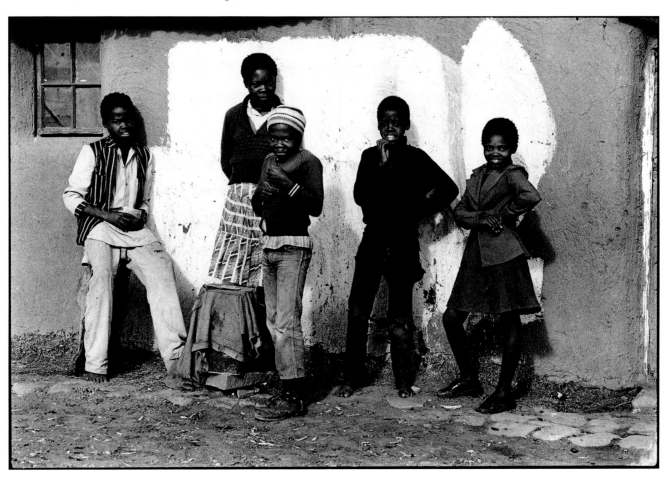

people in it have been relocated two or even three times from one camp to another. It was Oxton that the doctor at Thornhill had had in mind when he made his observation about the relationship between the number of relocations and child mortality.

As we walked through the cold sunlight between the huts Frances said that the doctor's correlation was scarcely surprising. 'Relocation destroys communities. The bonds within and between families are cut. Jobs are lost, so the father, and often the mother, must go off to find other work. The children are left with an aunt or a grandmother. The standard of living drops because, often, the grandmother's pension is the only source of income. Friends and neighbours may end up at opposite ends of a settlement or even in

Children, Oxton relocation camp, Ciskei

71

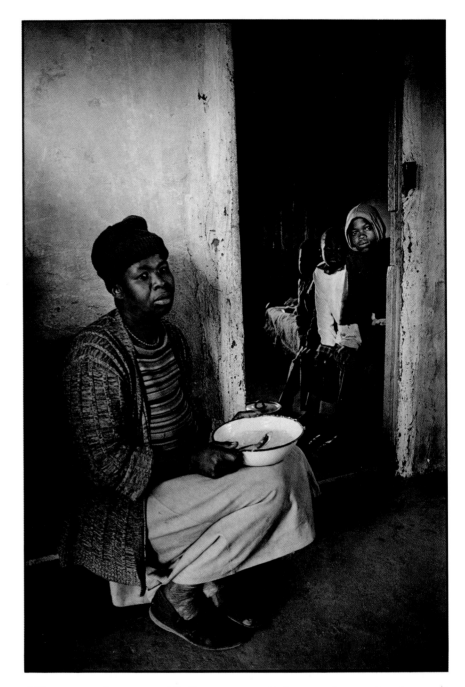

Mrs Batai and children, Oxton relocation camp, Ciskei

different settlements. All the support links people use in times of trouble are broken. And children are always the most vulnerable members of a community. They need stability. Disruption hits them first and worst. They become prey to every disease.'

In the first hut we visited, a pleasant, middle-aged woman ran a household consisting of her mother, her father (now in his dotage) and several children of various ages. They had been farmers in the Glen Grey district and had been moved to Whittlesea after Transkeian independence. Now they had been told that Oxton was to be closed and that they would have to move back to Whittlesea. Two of her younger children had died already with all the moving.

'All the same,' she said, 'I will be glad to go back to Whittlesea. This place is too far. There is no work here. Whittlesea is near

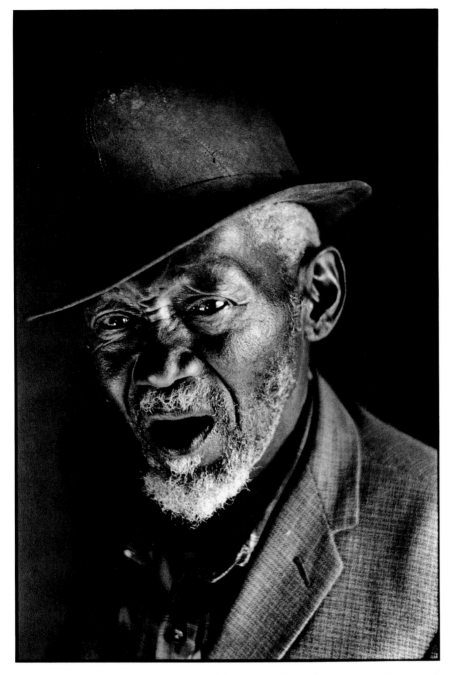

Old man, Oxton relocation camp, Ciskei

Queenstown and there's a good bus. Besides, there is no firewood here anymore. We have to pay a man to go with a tractor and cut wood for us. He goes far away: twenty miles up into the mountains.'

We walked on through the settlement, visiting more families. The whole place was very run-down, with many deserted and broken huts. The school also looked deserted and every window was smashed. It all said so strongly 'we hate living here' that it was quite surprising to enter the decrepit huts and find out how neat and clean people kept the interiors.

Another type of cleanliness disturbed me though. Most black townships throughout South Africa are surrounded by curtains consisting of the flapping remnants of plastic bags blown by the wind and caught on the barbed-wire fences. Yet here in Oxton, as in

Tentergate the day before, there wasn't a plastic bag to be seen. Could such fanatical civic cleanliness accord with the general dilapidated air of the place? I recalled a remark of Ina's: 'Plastic bags and refuse scattered about are a mark of relative wealth in a community. The worst places look clean because the people there are too poor to afford anything that comes in a plastic bag.'

Around noon we reached the clinic again just as Mpho and Zwayi drove up. The nurses brewed tea for us and we got our sandwiches out of the car for lunch, sheltering from the cold in the clinic tea-room. Then we said goodbye and drove on to Sada camp near Whittlesea.

At Sada hospital we saw the senior matron, a formidable black lady. There must be a special factory for matrons; all of them, black

▶ *Zwayi Pongoma and Mpho Mashinini weighing child, Emadakeni relocation camp, Ciskei*

▶▶ *Part of the Mangali family, Emadakeni relocation camp, Ciskei*

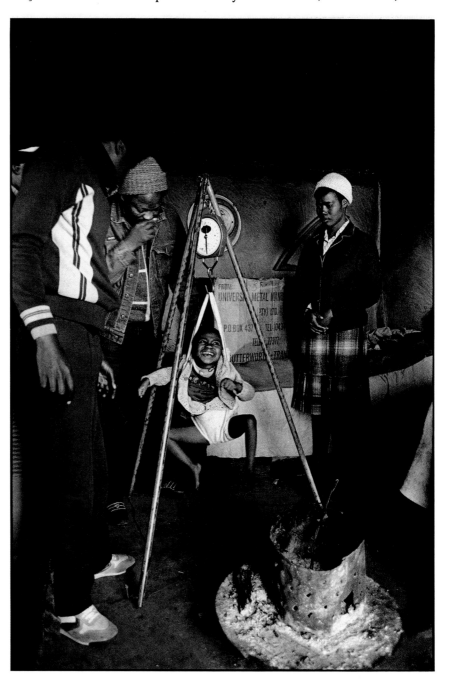

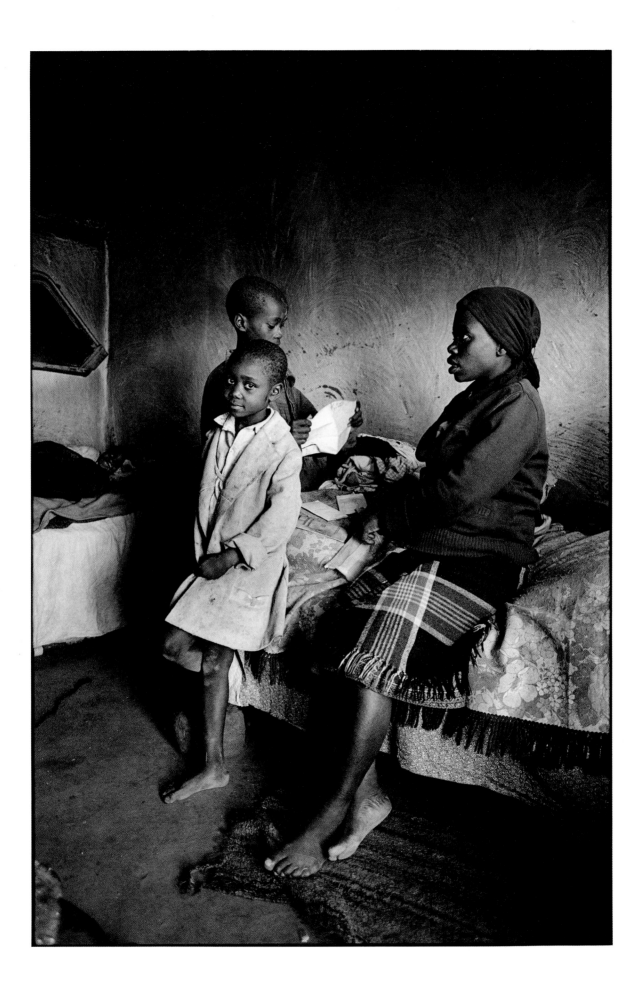

or white, have the same steel-clad manner designed to put mere doctors, nurses, patients and visitors firmly in their place. This woman heard Frances out in monumental silence, then told her, shortly, that the worst relocation camp in the area was Emadakeni. Quickly a senior nurse was summoned to guide us there.

Emadakeni proved to be a large township, part relocation site and part squatter camp, originally set up to supply labour to the Hewu industrial complex. Now it is overrun with squatters. As it was so large, we continued sampling until sunset. This time I went with Mpho and Zwayi in the Kombi.

It was appalling. I had thought Tentergate was bad the day before. I had thought I had seen the extremity of poverty in the small towns of Bahia in northern Brazil. But here *was* the extremity of poverty: hundreds of mud huts crammed together on narrow lanes, crowded with people who, it seemed as we interviewed them, had nothing. No food, no money, no jobs, nothing at all. Every child we studied, in every house we visited, was suffering from kwashiorkor, pellagra or marasmus. Many had tuberculosis. Several would not last out the year.

Frances, when our two teams met again at sundown, was equally appalled. A tough-minded woman, she had conducted many child malnutrition surveys in the Third World. She had even gone into Afghanistan, behind the Russian lines, to make a study of the children of the mujahidin. Yet she said that this, at Emadakeni, was the worst she had ever seen.

Mrs Nikani and child, Emadakeni relocation camp, Ciskei

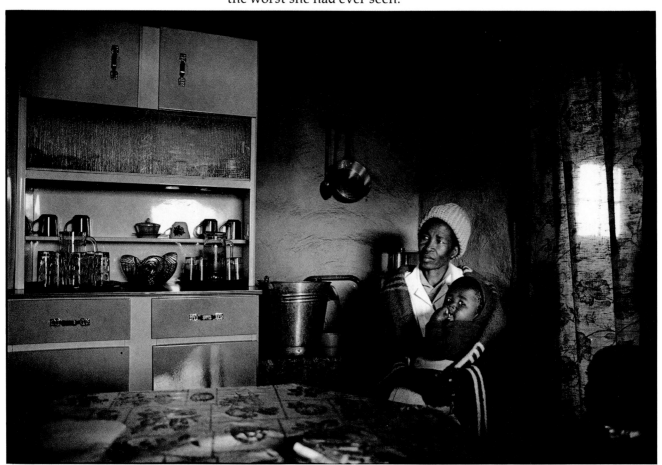

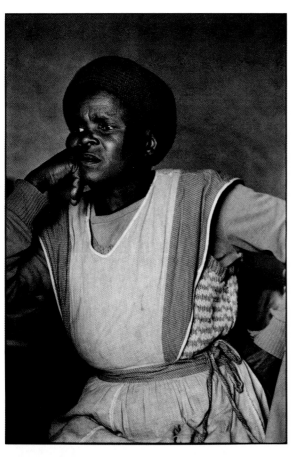

◀ *Mrs Pele, Emadakeni relocation camp, Ciskei*

▼ *The Ndebele family, Emadakeni relocation camp, Ciskei*

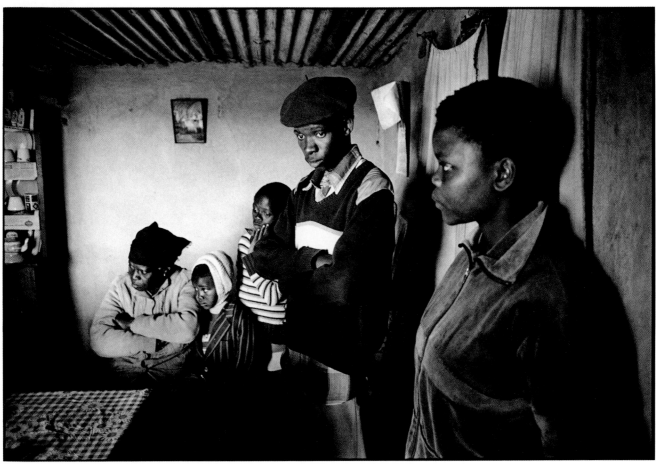

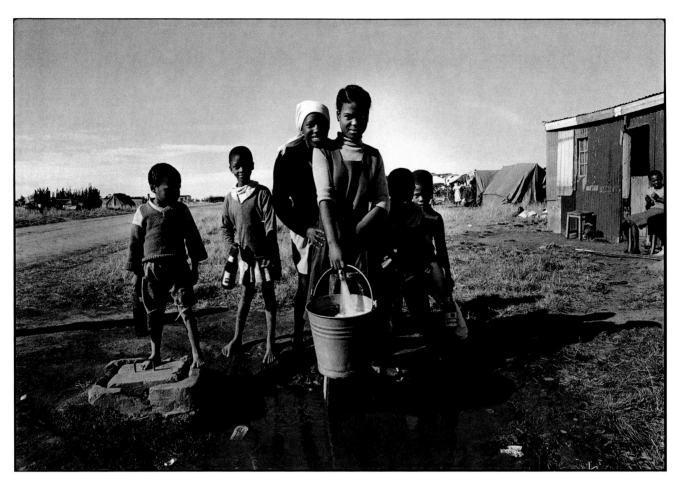

▲ *At the water tap, Frankfort tent town, Ciskei*

▼ *Underweight baby, Frankfort tent town, Ciskei*

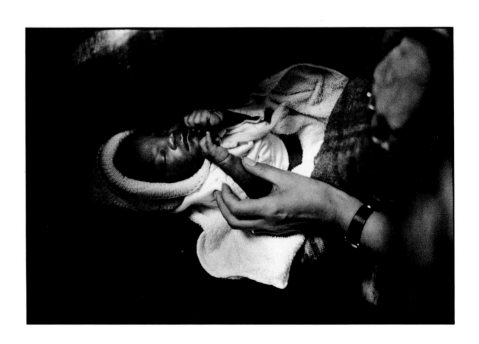

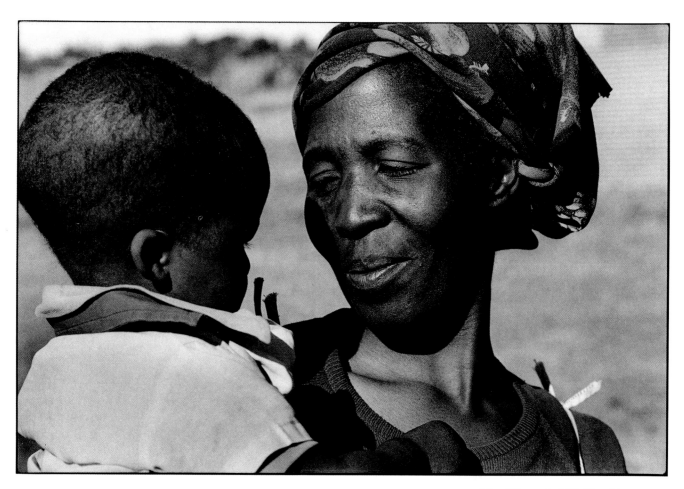

▲ *Mrs Tika and child, Frankfort tent town, Ciskei*

▼ *Mrs Tika's tent, Frankfort tent town, Ciskei*

East London is the nearest large city to the Ciskei, which pushes a finger of territory right up to its western suburbs: the huge township of Mdantsane, which supplies most of the labour for East London's industries. East London is yet another South African white community whose black dormitory suburbs have been 'disestablished' and moved off into a homeland.

The moving, however, is not quite complete. There are still small pockets of black residence here and there to mar East London's whiteness. One of these black spots is Duncan Village.

Florida Metele from the East London office of Operation Hunger took me there one cold, rainy day. She said that the East London municipality wanted people to move to Mdantsane. As we looked at the village, it seemed that they might have resorted to the tactic of reducing essential services. The houses, solid little brick cottages, with tin roofs and a Cape chimney up one end wall, were in a state of decay. Roofs were rusting. Broken windows had been replaced by cardboard.

Between the houses, squatter shacks of wood planking were jammed into every available space. The original hard-packed gravel roads had deteriorated into river-beds, with boulders and erosion gullies making driving an exercise in extreme care. There was no sewerage reticulation and refuse collection seemed to have ceased, for huge piles of garbage obstructed the sidewalks. As we entered the village we passed an enormous fire which turned out to be a blazing garbage-pile.

Operation Hunger runs several soup-kitchens in the village. East London's industry, like that throughout South Africa, has been badly hit by economic recession and the disinvestment of foreign companies. Most of the people in Duncan Village are out of work and dependent on charity feeding, but, in keeping with Operation Hunger's philosophy of self-help, the soup-kitchens are run by local residents. Operation Hunger provides the bags of soup powder but all the organisational work is done by the people of the village.

Usually, when I go into black townships I am not uneasy. I firmly believe that what you receive from other people is a reflection of what you bring to them. If you bring fear and suspicion, you will get back anger and hate. If you bring trust and human warmth, that is

◀ *Children, Duncan Village, East London*

exactly what you will get back. But in Duncan Village I was uneasy; there was an underlying anger which no amount of friendliness could dispel. These people had been pushed too far. I was glad to leave.

Port Elizabeth, 300 kilometres south-west of East London along the coast, is a much larger port city. East London has a sleepy, colonial air but Port Elizabeth is a bustling, working-class com-

▶ *People living in abandoned cars, New Brighton, Port Elizabeth*

▼ *Operation Hunger feeding line, New Brighton, Port Elizabeth*

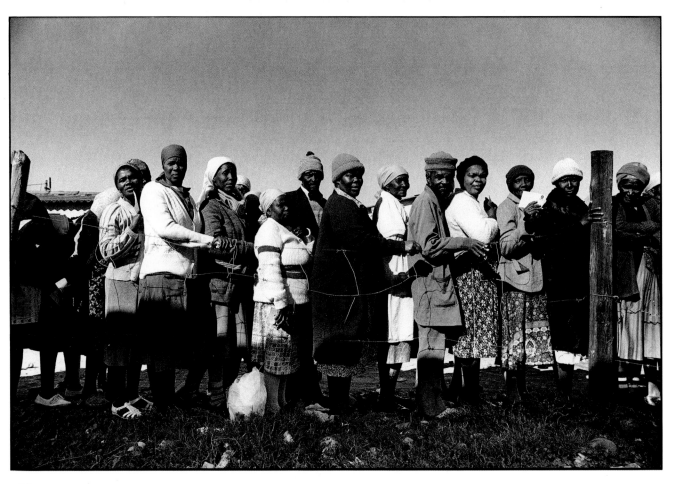

munity.

Or, rather, it was. At one time Port Elizabeth was the centre of South Africa's motor-car industry, the Detroit of the sub-continent. Then came disinvestment, economic recession and a drop in the demand for cars. The Ford Motor Company, the largest employer in Port Elizabeth, pulled out and sold its assets to Samcor, a division of Anglo American Corporation, South Africa's largest mining and industrial group.

Samcor decided to move the entire operation to its Pretoria factory and close down the old Ford car works. Thousands of people, mostly blacks, were thrown out of work. The Ford closure affected many more people than Ford company employees; all the sub-contracting firms dependent on Ford reduced staff or closed down. For the black population of Port Elizabeth it was disaster.

Women running Operation Hunger soup-kitchen, New Brighton, Port Elizabeth

Because of this high unemployment, Operation Hunger's Port Elizabeth office is heavily involved in feeding schemes. One bleak day of low cloud blowing on a chill wind off the sea, I visited Port Elizabeth's black townships. I went with Sheldon Lukwe and Toby Kombela in an Operation Hunger truck loaded with bags of fortified soup powder.

We went north on the Grahamstown freeway along the shore, then turned inland across the railway tracks into New Brighton. The first feeding point we visited was a yard filled with the battered, rusting remains of cars. As we drove in, a collection of ragged people clad in boiler-suits, old khaki greatcoats and balaclavas, crawled out of the cars to greet us. 'They live in those old wrecks,' Sheldon said, 'that is their home.'

The next feeding point, at a church, had a long line of people outside it, coiling around the block. There seemed to be thousands there, mostly women with a sprinkling of old people and children, all pressed tight against each other, waiting for soup. Although the scene resembled the Botswana village I had seen twenty years before, here the community was helping itself. The people had got themselves together, decided that they needed supplementary

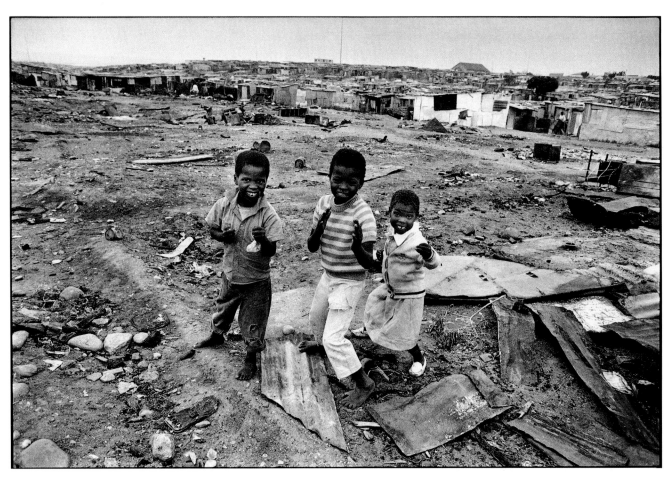

▲ *Children in burnt-out section of
Soweto squatter camp, Port Elizabeth*
▼ *Children, Motherwell squatter
camp, Port Elizabeth*

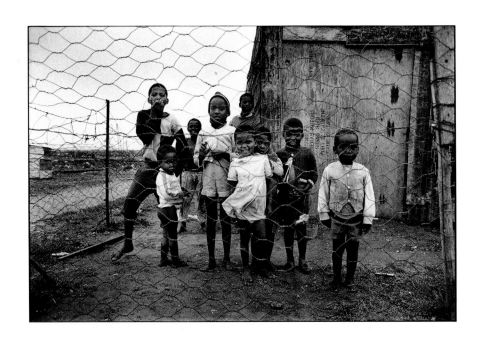

feeding, organised the cooking and the venue and then had asked Operation Hunger to help. Operation Hunger had not forced its help onto the community.

Beyond New Brighton we came to the squatter camp of Soweto, a jumble of tin and plywood shacks in a valley leading down to a vlei. Rotting garbage was piled up in the mud lanes that ran between the houses and a stinking open sewer ran down the centre of the camp into the vlei. The huts were dangerously close together. At one place fourteen shacks had burnt down. The fire had started in one and spread across the whole block, burning shacks, furniture and parked cars. All that remained were some rusted hulks of cars and some blackened pieces of fire-warped corrugated iron from the roofs.

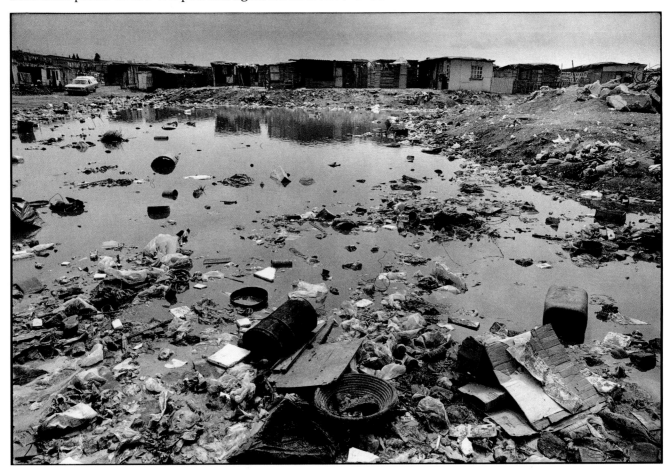

In Kwazakhele camp the soup-kitchen was in one of a number of shacks clustered round a huge puddle. Garbage lay mouldering along the shore and the water itself was a poisonous milky pink. Children were playing round the edges and I wondered what awful chemical had given the water that evil colour.

From Kwazakhele we went back to New Brighton and visited the Red Location. Set out on barren beach-gravel, just west of the main railway line, were rows of small gable-ended houses made of corrugated iron. Originally one of three army camps (the other two being White and Blue Locations), it had been built at the turn of the century as transit accommodation for British troops being shipped to the Boer War. The wind and rain of 88 years had long since stripped

Kwazakhele squatter camp, Port Elizabeth

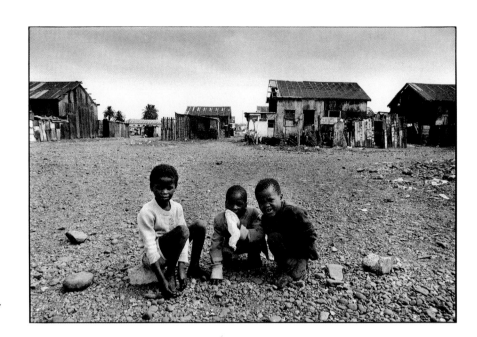

▶ *Children, Red Location, New Brighton, Port Elizabeth*

▼ *Sick people in house in Red Location, New Brighton, Port Elizabeth*

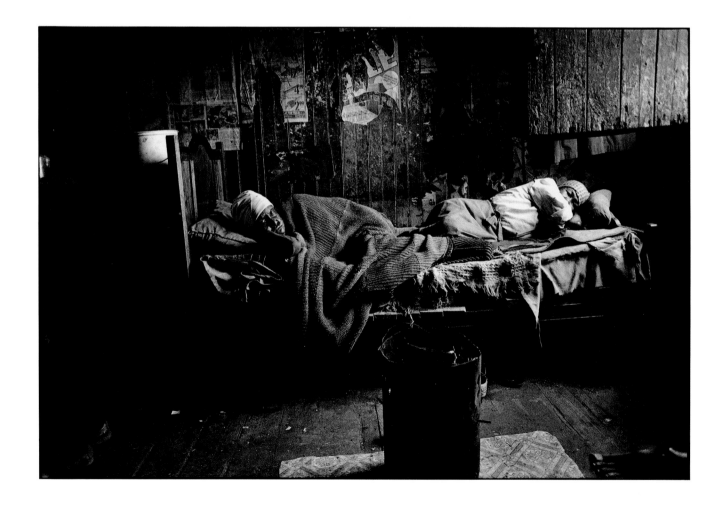

the metal, not only of paint but also of galvanising. The salt sea air had got to work and now the houses were the rust-red colour of the haematite their iron sheets had been fashioned from. Gales had pulled off roof panels and salt had corroded holes in roofs and walls.

Yet people were living there. We entered one house where the wind whistled through gaps and found eight people wrapped in blankets on four beds, two to a bed and all sick. The wooden ceiling above them was rotted with damp and through gaps I could see sky where the iron roof had rusted away.

As we went back to town along the freeway, with the grey silhouette of central Port Elizabeth ahead over the green sea, I found myself seething with anger. Places like Red Location are, in the truest sense, obscene: 'repulsive, loathsome, repugnant' as the *Concise Oxford* gives it.

Red Location, New Brighton, Port Elizabeth

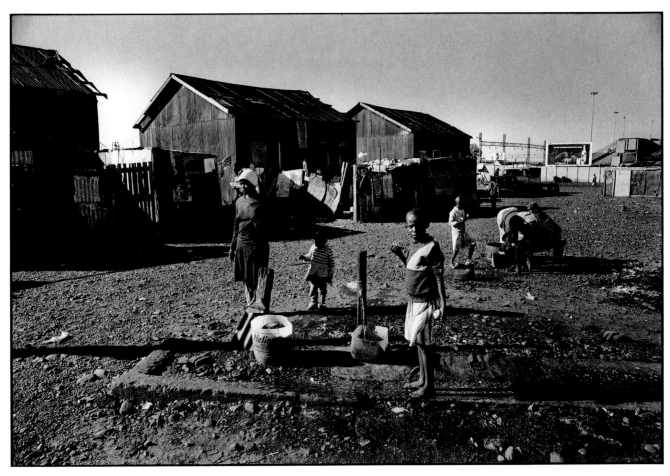

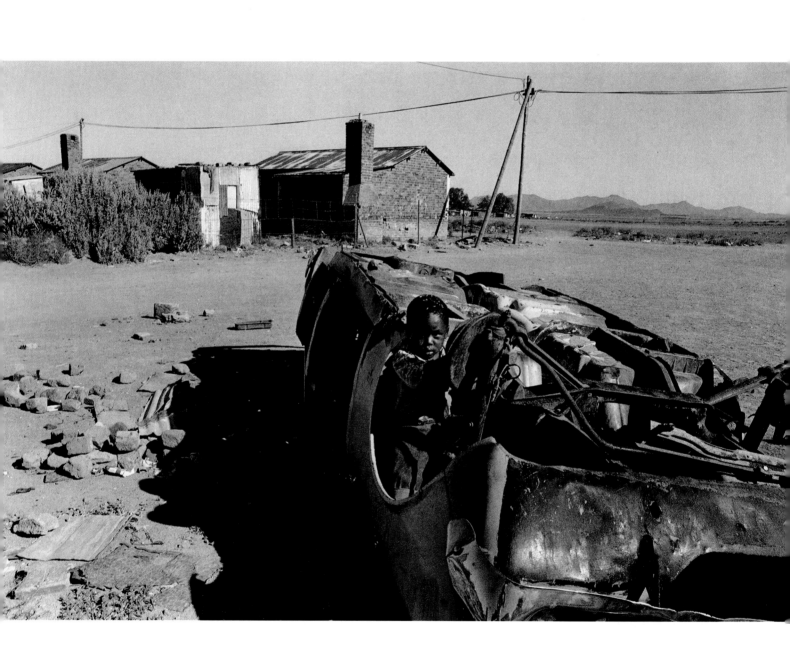

Karoo

The Great Karoo has always been one of my favourite parts of South Africa. A semi-desert, it lies between the Great Escarpment and the Swartberg range. Its pale orange sand, the sage-green of its Karoo-bush and the blue of its distant mountains, all held in a sunlight of extreme clarity, give it a severe beauty. The small towns scattered across its vast expanse, Beaufort West, Aberdeen, Willowmore, Graaff-Reinet, have a grace which comes from long settlement, for this was one of the first areas to be colonised by the farmers who left the Cape in the eighteenth century. And the coloured people of the Karoo, descendants of the original Khoikhoi, interbred with Malay slaves and white settlers, have a grave dignity which accords with the white buildings and dark cypress trees of the little towns.

At least, this was the way I had always seen the Karoo until I set off from Port Elizabeth one bright February morning to visit the 'locations' of those Karoo towns with Operation Hunger. We went inland past Uitenhage into the euphorbia bush of the Eastern Cape. The road ran between two ridges, the eastern end of the Groot and Klein Winterhoekberge, here little more than hills as they curved towards the sea. Then the road swung north over the Klein Winterhoekberge and the pale pinkish-yellow of the Great Karoo opened out ahead.

It was already hot when we reached Jansenville township. In the middle of this drab collection of sun-dried brick and rough stone huts, we found an Operation Hunger soup-kitchen. A backyard between a tumbledown outhouse and a derelict car contained two women boiling up a huge iron pot of water. Toby Kombela unloaded soup powder and soon a delicious brown soup was simmering away.

Children came down the road from the local school, toddlers first and then the larger boys and girls. They lined up in the road outside the gate with their plastic mugs, old yoghurt containers, or jam tins, and trooped in one after another to receive their cup of soup. Afterwards the older pupils gathered round the gate and sang us a lovely Xhosa song.

From Jansenville we went on across the Karoo towards Graaff-Reinet in the morning heat. Amid the blue jumble of mountains ahead, the characteristic outline of Spandau Kop began to take shape. So often I had come across the plain and seen that koppie as

◀ *Child in Midross location, Middelburg*

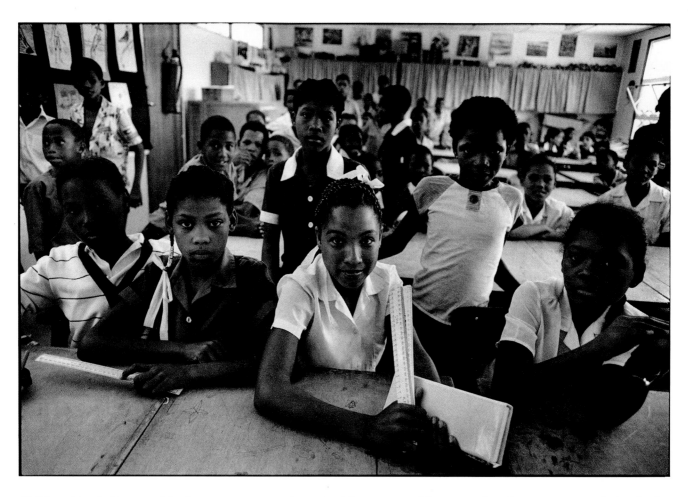

Children, Lincoln Primary School, Graaff-Reinet

journey's end. After it would come the clean streets of the little town, the carefully preserved buildings gleaming white, the Dutch Reformed church blocking the end of the main street and the welcome shade of the old cypress trees.

But not today. Today, under the shoulder of Spandau Kop, we turned onto a potholed dirt road and entered one of Graaff-Reinet's three townships. Dust, rubbish, rusting cars, a burned-out school: these were aspects of the reality behind the façade of white walls and shade trees which I had never bothered to penetrate before. I was getting a black person's view of Graaff-Reinet. I could never look at the Karoo in quite the same way again.

At the house of the principal of the Lincoln Primary School we were greeted by his wife, Mrs Martin, a white-haired matron of immense dignity. She led us into the welcome cool of her front room and gave us tea.

'Tea' was an understatement. Besides tea, and coffee for those who preferred it, there were plates piled with sandwiches, scones, *koeksisters* and cake. In every respect, in the furniture and decoration of the room, in the food and the unstinting hospitality with which it was offered, it reminded me of similar teas I had been offered in similar, if more sumptuous, houses in the white part of this same town. Indeed, Mrs Martin herself, save for a trivial difference in the shade of her skin, was sister to those hostesses who resided on the other bank of the Sundays River.

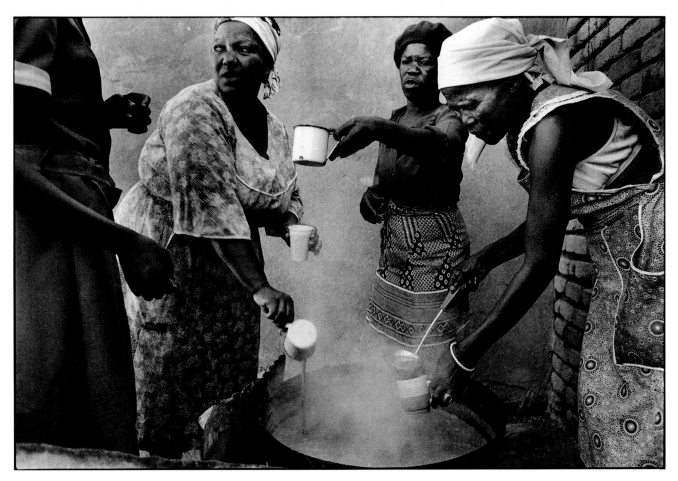

After tea we visited some of the township feeding points. Mrs Martin told us that there was 70 per cent unemployment in Graaff-Reinet and that that percentage was typical of most Karoo towns. All of them are agricultural centres with no heavy industry, and farming has been hard hit by both drought and recession.

Up the hill, in the Old Location, which Dr Doreen Greig of the Wits University architectural department once claimed was the

▲ *Operation Hunger soup-kitchen, Jansenville*

▼ *Woman sewing dress, Municipal health centre, Old Location, Graaff-Reinet*

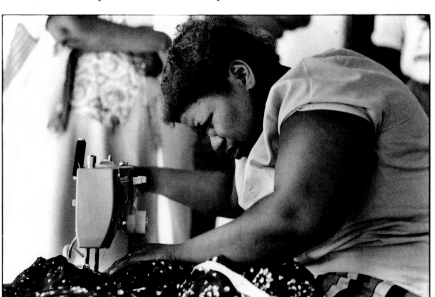

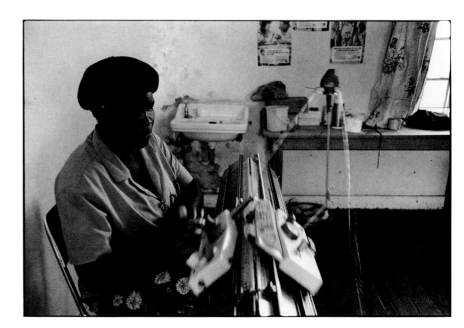

▶ *Woman knitting jersey, Municipal health centre, Old Location, Graaff-Reinet*

▼ *Carrying water, Midross location, Middelburg*

finest surviving example of indigenous Cape architecture, we visited the municipal health centre. Here we saw a self-help scheme where women were making dresses and cardigans on sewing- and knitting-machines donated through Operation Hunger. The clatter of the sewing-machines and the ripping noise of the knitting-machines affirmed that, despite crisis feeding, Operation Hunger's long-term goal of development through self-help was being pursued.

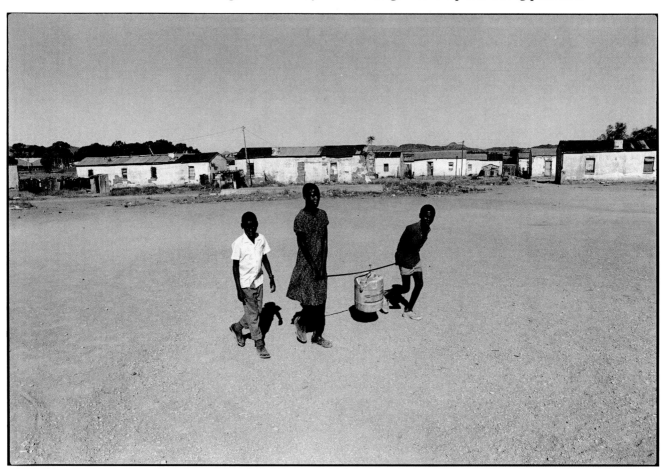

Glynis Baer, Port Elizabeth regional director of Operation Hunger, buying handicrafts in Somerset East

We drove on over the Sneeuberg range to Middelburg where the Reverend Mr Wilmot and his wife were waiting at the Anglican church with a group of community leaders to discuss Operation Hunger's projects in that area. After this discussion, and lunch, Canon Wilmot took us on a tour of the Middelburg townships.

The older township Midross was a depressing collection of decrepit brick houses, many of them in ruins, with no proper water reticulation or sewerage. The mood of the people we met was sombre, with much anger and bitterness. Canon Wilmot said that Midross had been allowed to decay as people were to be moved to the new township a couple of kilometres out on the Richmond road. He said that people were glad to move to the new township with its better houses, water and street lighting, but, when we visited it, the

mood of the people there did not seem much better.

We had been scheduled to go on to Colesberg but it was now so late that Ina called it off and we went back to Graaff-Reinet through the golden light of late afternoon. By ironic contrast to the poverty and squalor we had seen all day, we stopped for the night at the Drostdy Hotel, part of the restored centre of the town. As an even greater irony, our rooms were in the done-up 'slave quarters', the former homes of people whose descendants now inhabit the townships we had visited that morning.

Next morning in Somerset East, at the town clinic, we found a thriving little self-help project with women making Xhosa beadwork for sale. The nurse in charge took us on a tour of Somerset East's three townships. We visited various soup-kitchens in private homes

Women making beadwork, Somerset East clinic

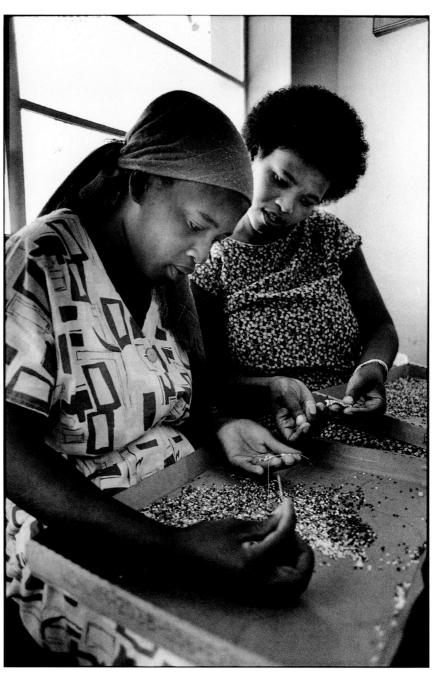

or church halls. At one church we found feeding in progress. Under a makeshift shelter beside the church a crowd of women and children, all clutching plastic mugs, old jam tins, or cooking pots, waited patiently in line for their share of the thick brown soup simmering away in three iron pots.

By now it was blazing noontide and we went on through the mountains, leaving the Karoo plains, to Cookhouse. Cookhouse is a junction on the main railway line from Port Elizabeth to Johannesburg, a tiny huddle of houses dominated by a huge railway coaling gantry. The township was as bad as Jansenville or Middelburg, yet even here we found a self-help group busily at work producing clothes and beadwork. It was run by a formidable lady, Mrs Feyte, who refused to consider any possibilities other than the improvement of everyone's lot.

Family, Somerset East location

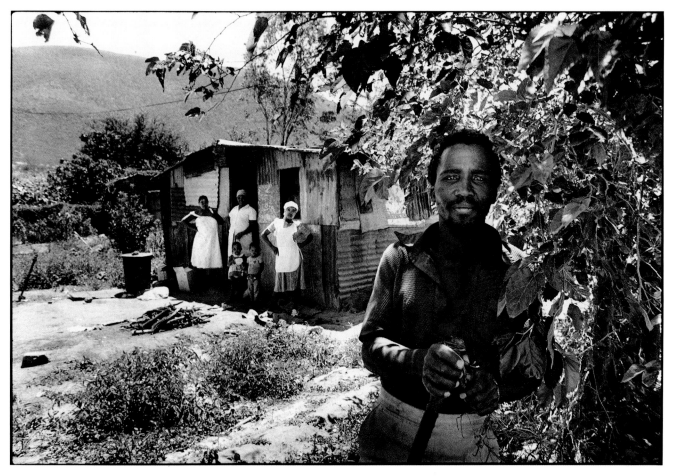

▶ *Operation Hunger soup-kitchen, Somerset East*

▶▶ *Producing Xhosa beadwork, Cookhouse*

▼ *Sewing dresses, Cookhouse*

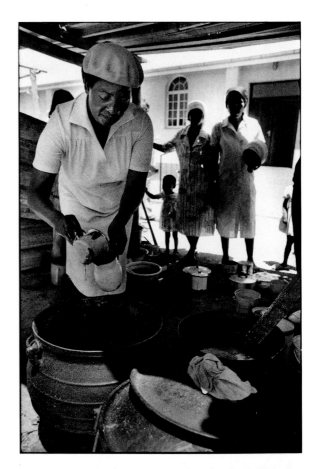

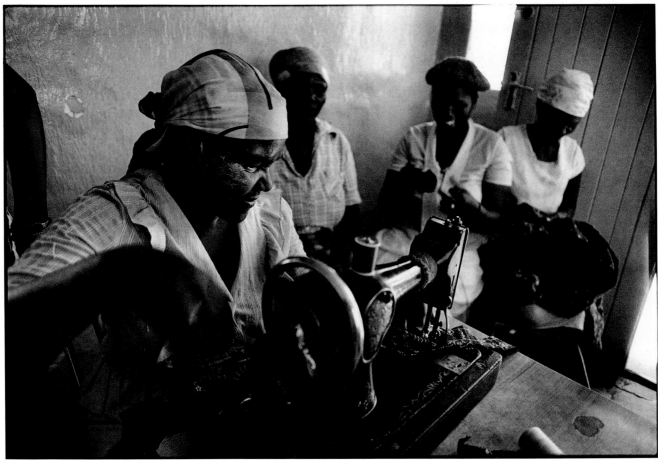

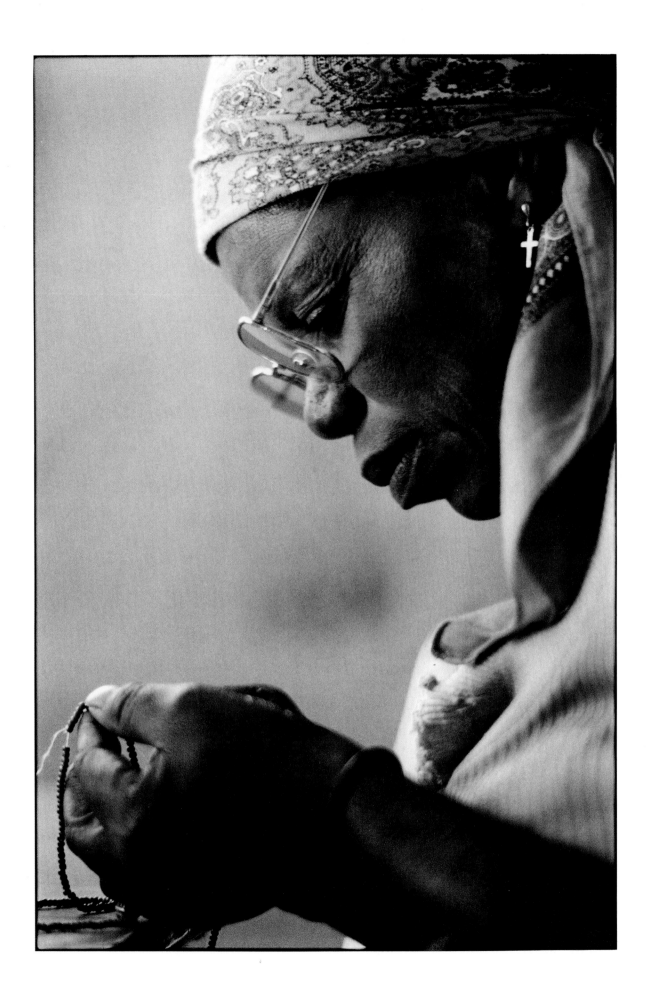

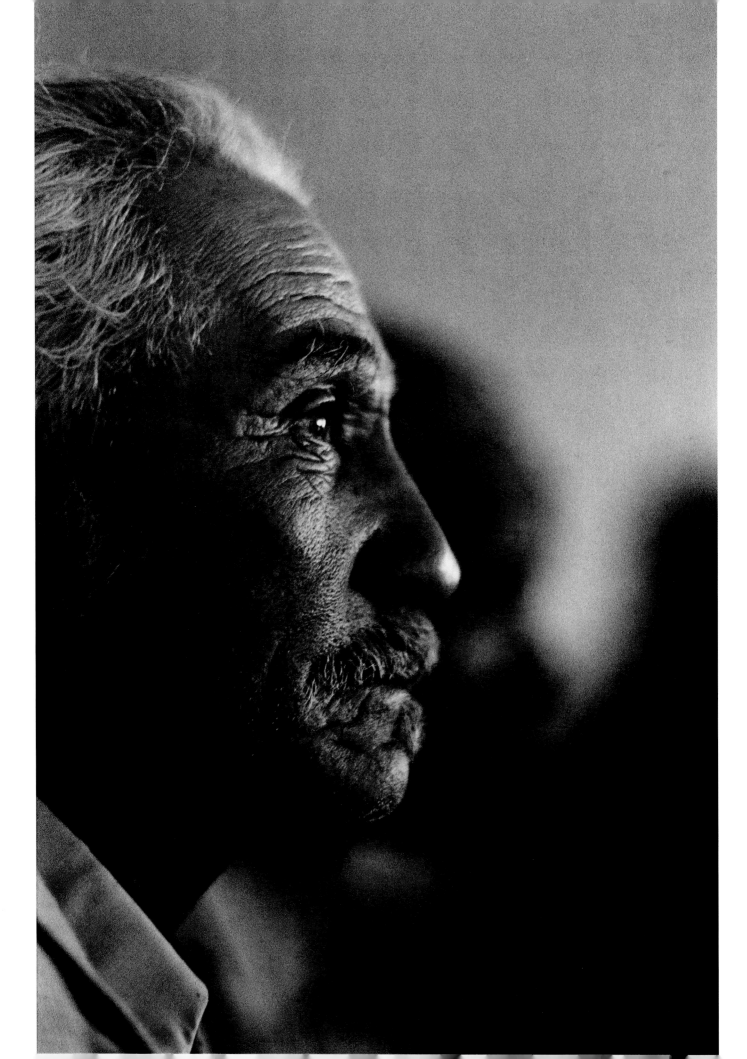

Namaqualand has always been a place of refuge. Apart from the copper near Springbok there are few minerals, while the poor soil and scarce water were further discouragements to colonists. Thus the Khoikhoi could safely retreat there before the expanding settlers from the Cape. Renegades from the colony escaped north and joined the tribes, bringing the firearms and military training which formed the basis of the Baster warrior-clans in the nineteenth century. Then, after 1948, the Nationalist government in Pretoria classified the descendants of these people 'coloured' and set aside the country north of Springbok for them, with Steinkopf as its administrative centre.

Early in the southern winter of 1987 I flew to Namaqualand, accompanying Ina Perlman on a survey trip to the farming groups around Steinkopf who had asked for Operation Hunger's help. At Springbok airstrip we were met by the regional director of the Western Cape, Roselle Frasca. After visiting a mission crèche in the mining village of Concordia, we set off north towards Steinkopf.

To get a better idea of the sort of country we were dealing with, we left the main tar road for a narrow gravel track which wandered off through granite tors and across sandy plains cut, here and there, by dry water-courses. This twin-rut track led us from one small settlement to the next, each cluster of mud huts and Nama *matjieshuisies* huddled close around the wind-pump which gave it life.

The *matjieshuis*, or mat-hut, is the traditional Nama dwelling. Beehive-shaped, it is erected on bent twigs and in the old days the covering consisted of reed mats. Similar in design and purpose to a Mongolian yurt, it is the shelter of a nomadic people. Nowadays, with fences and property rights restricting nomadic wandering, the *matjieshuis* serves as cheap housing for the poor in every Namaqualand 'location'. Constructed now of plastic sheets and sacking, it has acquired a truly twentieth-century air of sleaziness.

After hours of meandering through the desert, we reached Steinkopf and stopped at the Administration Building for a meeting with the local farmers. A large crowd was awaiting us, many of them with triangular Khoikhoi faces wrinkled by the fierce sun. Others, solid and beefy, could have been white Afrikaners or even Germans.

In the following hours of discussion with the Operation Hunger team it was soon evident that each of these people, men and women,

◀ At Farmers' meeting, Steinkopf

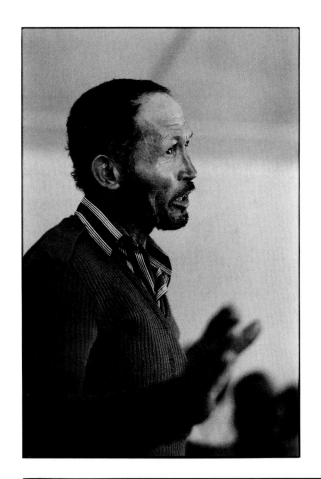
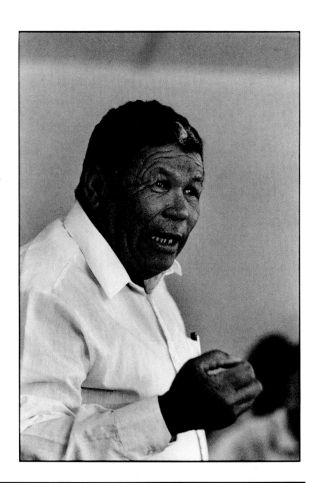

was a fiercely independent individual, yet with a strong sense of communal solidarity. They reminded me of Scottish clansmen, each a part of a group, yet each a free spirit. Despite the present-day clothes they wore, it was easy to see them as descendants of the Nama tribesmen who had parleyed with Simon van der Stel when he first reached Namaqualand from the Cape colony, three hundred years ago.

During the next three and a half days I accompanied the Operation Hunger team as we visited the various farming groups: Uitkyk on the crest of the Anenous Pass, where we could look down to the distant sea, Kasteelpoort where a stretch of fertile ground lay between huge granite domes, Eyams on a large upland dominated by

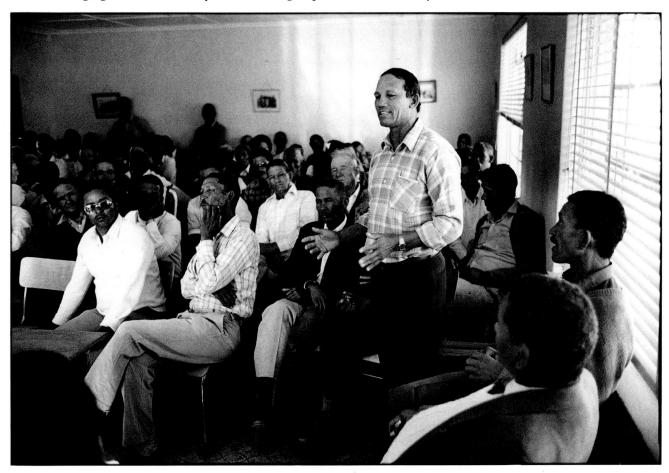

◀ ▲ *Farmers' meeting, Steinkopf*

the ruins of a stone house, Bulletrap amid hot hills, Henkries in the savage mountains of the Koa valley, where a date-palm plantation throve on ground so salty it was covered with white crystals, and Goodhouse in the gorge of the Orange River. From it all I formed a picture of stubborn people living on the very edge of survival.

Since then, with Operation Hunger's help and funding from the Anglo American Corporation's Chairman's Fund, the Steinkopf people have begun to pull themselves above the survival line. Forming a farming co-operative, the groups elected a steering committee and appointed an agricultural manager, Jan Geertsema.

Israeli advice on desert farming techniques was called upon and each group now has a borehole, piped water reticulation and

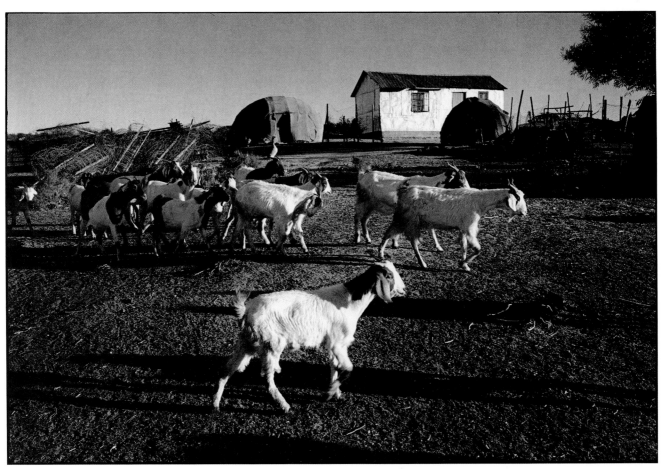

▲ *Goats at sunrise, Uitkyk, Namaqualand*

▼ *Farm school, Koegas, Namaqualand*

reservoirs. All the groups have produced crops of lucerne and wheat and each has ten hectares of vegetables under cultivation. The coastal diamond-mining town of Kleinsee has agreed to buy vegetables from the co-op, thus giving them an assured market. At Steinkopf itself, over fifty garden plots have been started and, with incredible luck, an old artesian well was struck which gave such a flow of water that it took two days to cap it.

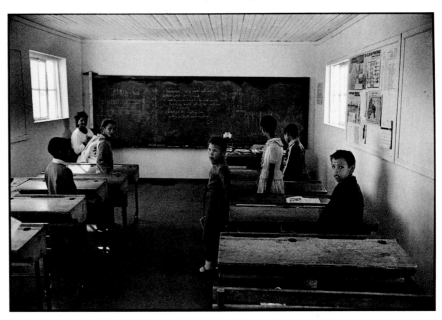

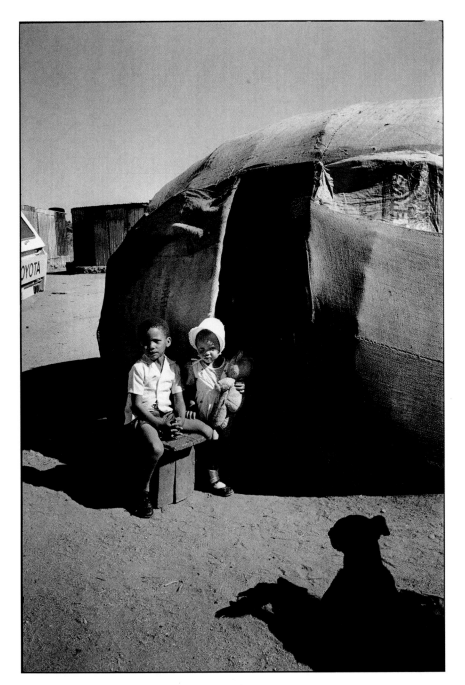

Children and matjieshuis, *Eccosis oasis, Namaqualand*

There is an agricultural centre where research is being done on the best varieties of crops to suit Namaqualand conditions. Training courses for farmers are also held at the centre to improve farming techniques. A fence-making group specialises in making jackal-proof fencing for sale.

The co-op pays for seed, fertiliser and ploughing costs out of the money received for their produce, so that the project is on a solid commercial footing. Eventually the Chairman's Fund will withdraw completely and Operation Hunger will remain on a purely advisory basis. The aim is complete self-sufficiency. As Ina said to me: 'Basically Namaqualand is OK, the community is taking over.'

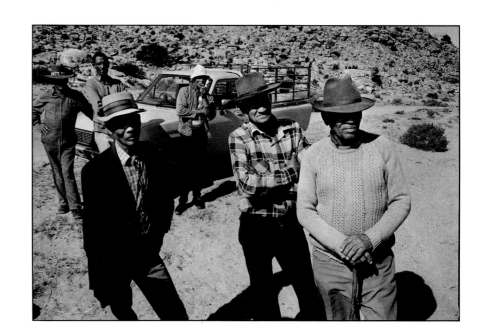

▶ *Farmers from Bulletrap, Namaqualand*

▼ *Donkey cart near Bulletrap, Namaqualand*

▶▶ *Children at crèche, Okiep, Namaqualand*

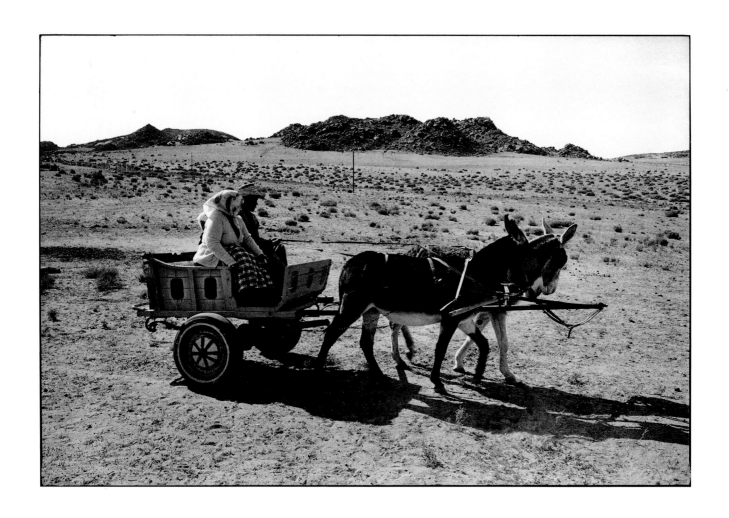

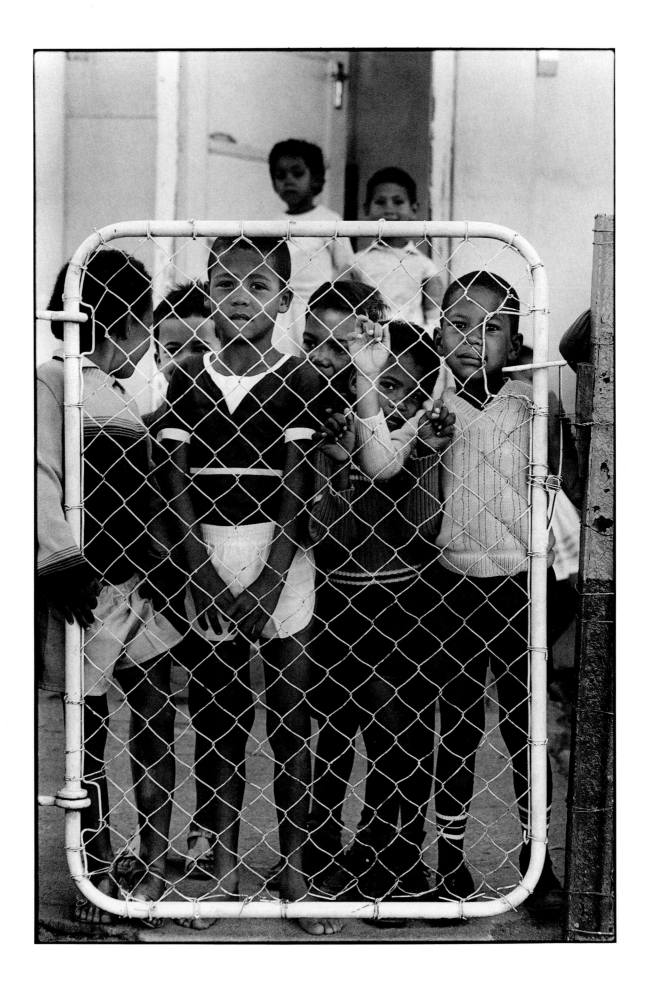

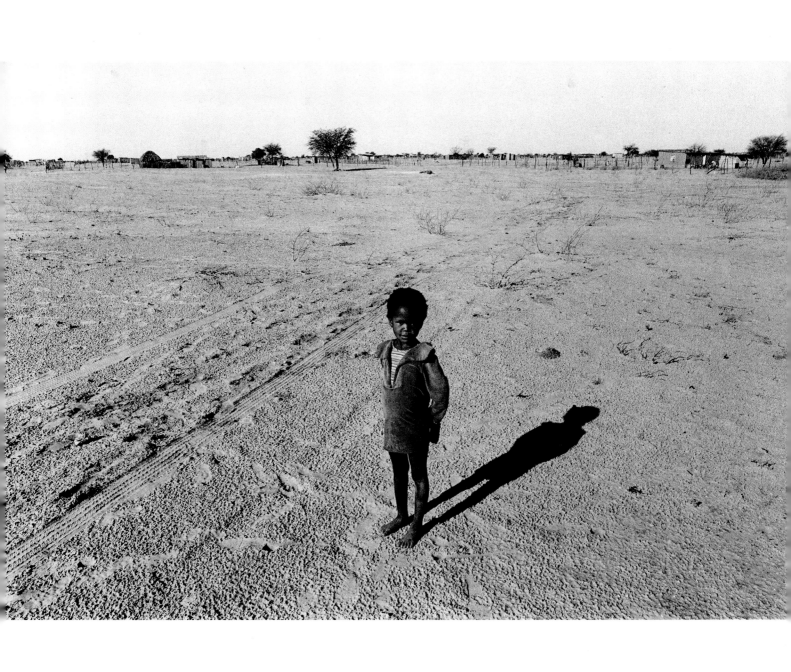

'This may well go down in history as one of the worst social experiments of the twentieth century.' The priest's voice was soft with the accent of his native Cork, but there was no disguising the bitterness. We stood on a low Kalahari ridge, 90 kilometres north of Kuruman, looking down across the dry bed of the Moshaweng River towards the settlement of Slough.

◀ *Child, Padstow relocation camp, Kalahari*

Despite its English name, Slough, like its neighbours Bendell, Dearham and Padstow, is no English village. They are all relocation camps; rows of mud huts scattered across empty sand without a single tree to give shade. Into these barren wastes have been poured the people of Douglas, Schmidtsdrif, Daniëlskuil, Griquatown and Postmasburg. Once peasant farmers whose forefathers had owned all that land under Tswana, Koranna or Griqua chiefs, they are now part of the more than three million people displaced by the dream of complete territorial apartheid. In terms of the Bantu Commissioners' General Circular 26 of 1968 they are 'non-productive Bantu ... superfluous in the labour market.'

Certainly Mr and Mrs Molope of Padstow were 'superfluous in the labour market'. Pensioners in their seventies, they said they drew a sum which totalled R80 per month. On this they supported fourteen children and grandchildren. The young men of the family were away working, but they contributed little. Because of the worldwide asbestos slump the main industry of the Kuruman district, asbestos mining, had ceased. They were reduced to labouring for local white farmers.

This is hard and unrewarding work. Farmers come to the camps with trucks and promises of wages but often, after people have been transported to the farm, it turns out that food and accommodation charges are deducted from these wages. Sometimes people end up working for a few bags of maize-meal to take home. If they are in the position of the three Molope young men, with many dependants at home, this is hard on the whole family. Ina says that each black person with a job supports an average of twelve other people, yet black wages, especially in farming, remain abysmally low.

The grandmother, Mrs Molope, had lung problems and should have made regular visits to the out-patients' clinic at Batlharos hospital near Kuruman. But the bus fare from Padstow, plus the taxi fare to the hospital, plus the clinic fee, all cost her half her monthly

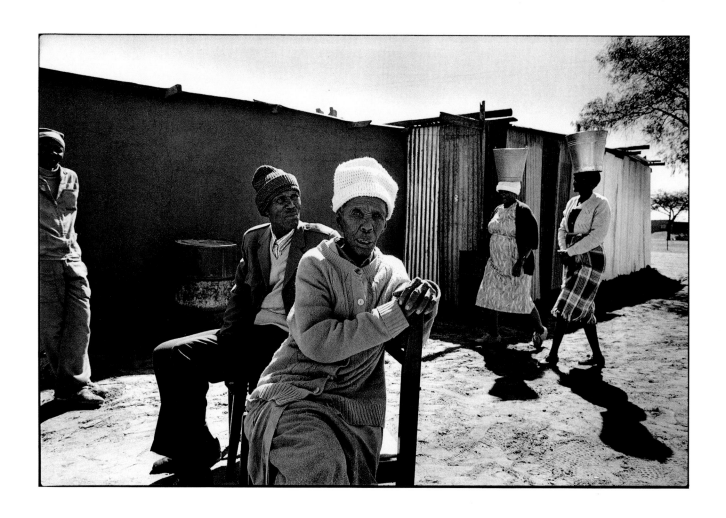

▲ *Family, Bendell relocation camp, Kalahari*

▶ *Unemployed men, Bendell relocation camp, Kalahari*

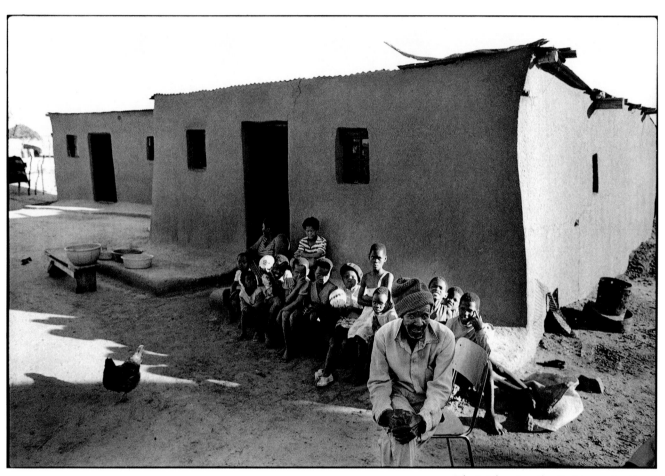

The Molope family, Padstow relocation camp, Kalahari

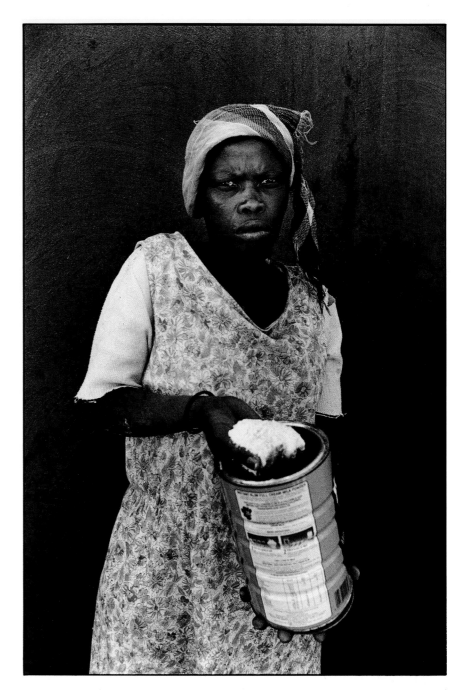

Mrs Bashi with a can of maize-meal (part of her payment in lieu of cash wages for work on a local farm), Padstow relocation camp, Kalahari

pension so she couldn't visit the clinic very often and her condition was slowly growing worse.

All the same, the Molope family was well-off by Padstow standards. They had two pensions and three fit young men. One of their neighbours, Mrs Bashi, had no regular income. Her husband deserted her after their last child was born. Her brother was crippled in a mining accident and was dismissed with a lump-sum payment which had long since gone in keeping the family alive. Her mother was a second wife and did not qualify for a pension.

Mrs Bashi was supporting herself, her brother, her sister, her mother and six children by sewing or washing clothes for slightly better-off families like the Molopes. In addition she and her sister worked as casual labourers on white farms whenever the op-

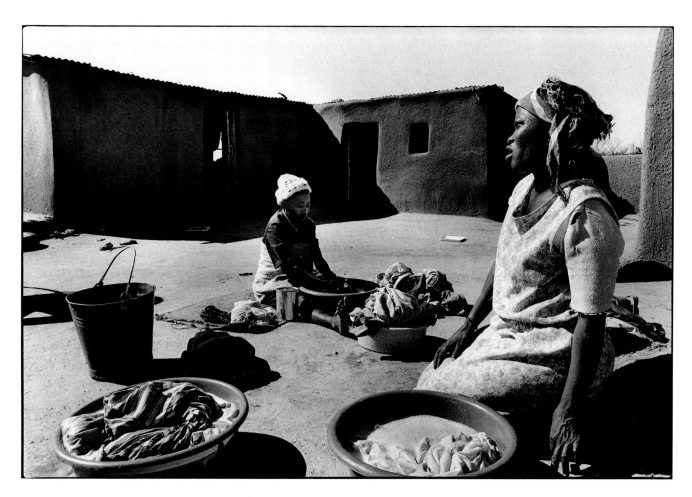

Mrs Bashi and her sister-in-law on their lapa, *Padstow relocation camp, Kalahari*

portunity presented itself. The summer before we visited Padstow, the two women worked an entire season for four sacks of maize-meal. This had been the staple food of the family every since.

This general dependence on maize-meal means that deficiency diseases like kwashiorkor and scurvy are rife in the camps. Why did no one grow vegetables? The Irish priest said: 'You should talk to Brother Robert about that.' Brother Robert was the Catholic mission's agriculturalist. He had constructed a vast vegetable garden, several hectares in extent, along the banks of the Moshaweng at Slough. People were encouraged to cultivate plots in it. Seed, plus water from boreholes along the river, was provided by the mission and Operation Hunger.

'The real problem for these people, apart from the lack of water, even from boreholes, anywhere away from the river-beds, is that this sand is infertile,' he told me. 'We truck in tons of fertiliser every month just to keep this garden, and the ones at Bendell and Dearham, going. Without fertiliser this sand will grow nothing but tsama melon and thorn-scrub.'

As Frances D'Souza pointed out, relocation breaks up communities. Friendships are lost, kinship ties are broken. People find themselves adrift with no help to turn to when relatives fall sick or die. In Slough we found a house full of children whose mother had just died. Their father was in Batlharos hospital with TB, they had no relatives in Slough, and the eldest child was 13. Their only hope

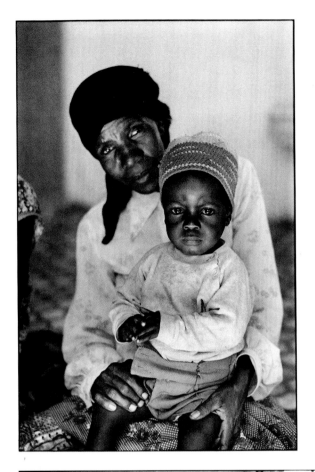

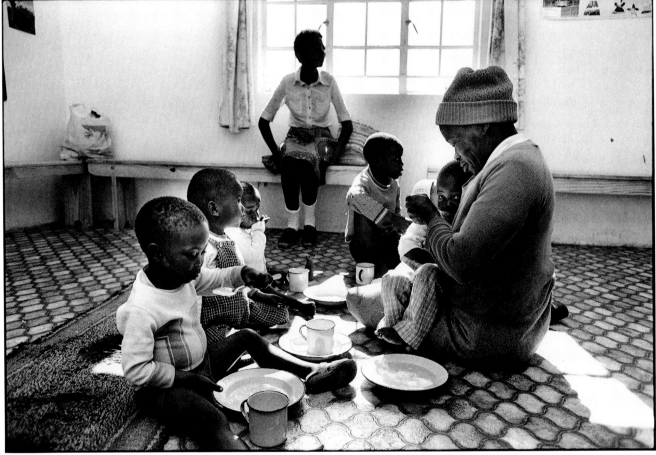

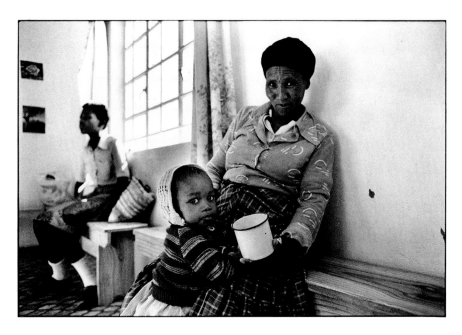

◄◄ *Children at clinic, Bendell relocation camp, Kalahari*

▼ *Malnourished children, Dearham relocation camp clinic, Kalahari*

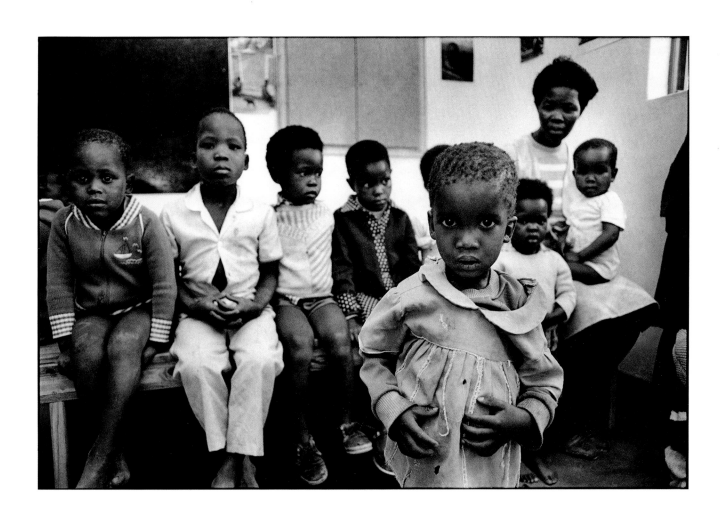

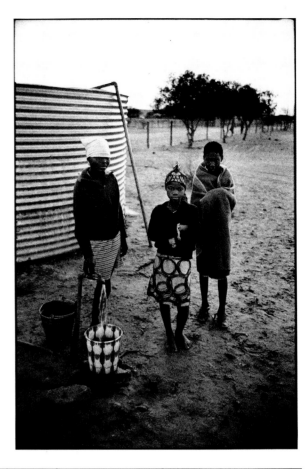

▶ *Fetching water at dawn outside mission, Slough relocation camp, Kalahari*

▼ *Children at borehole, Slough relocation camp, Kalahari*

The Mosala family, Slough relocation camp, Kalahari

was the mission and Operation Hunger.

'Oh, but they're feckless, these people. They have far too many children. Why doesn't Operation Hunger promote birth-control?' This remark, edged with either scorn or anger, comes up again and again in conversations about Operation Hunger. Perhaps Ina's answer is the simplest: 'If you work all your life for subsistence wages, hand-to-mouth, how can you put anything away for your old age? Your only hope of avoiding starvation when you are too old to go on working is a large family who will, hopefully, support you. For most blacks, children are their old-age insurance. The only way to encourage black people to have fewer children is to pay them realistic wages, the same wages you would pay a white person.'

Sekhukhuneland today presents quite a different picture from that which I saw on my first visit in 1986. For a start, the big vegetable garden at Moretsele has become a successful, year-round garden. Even in winter it is green. At the edge of the garden a large threshing floor has been constructed and people are busy threshing and winnowing sorghum.

Why sorghum? One of Ina's pet hates is maize. Besides having low food value, it is a very thirsty plant. It evolved in Central America, in a climate of high rainfall, on rich volcanic soil. In Africa it requires too much irrigation and fertiliser. She favours sorghum, a grain which evolved in Africa and is better suited to dry conditions and poor soil. At first people were sceptical because they had traditionally used sorghum to make beer and did not see it as a food grain. However, Ina can be very insistent and her insistence is beginning to pay off as more and more people plant sorghum instead of maize.

In Jane Furse and the neighbouring villages all sorts of self-help projects have begun, from a home watering-can factory to individual kitchen gardens and a chicken-breeding programme. Wood-lots of fast-growing species of trees are being planted to provide firewood as a crop and thus stop the denudation of the hillsides.

Down at Ngoabe the fencing tables are still in full production. I had not realised, until Ina told me, that fencing has a continual demand. 'Basically when do people fence? When they want to keep the goats out so that they can plant their fields. Fencing is actually seasonal.'

The Ngoabe sewing group is doing well. They now have their own label, which they proudly attach to each garment. They have begun to work on contract; for instance all the local soccer clubs have ordered track-suits from them.

Johann Rissik drives me north-east across a sun-seared land. Withered thorn-trees raise gaunt branches to the hot sky and the granite sand glitters in the sun-glare. Goats search for grazing amid the leafless scrub. Here and there the green of prickly pear merely emphasises the dryness. Johann says the good rains over the rest of the country have not reached Sekhukhuneland. They have now had most of a decade without adequate rain.

Dark blue hills crowned with rocks rise ahead of us. Beneath them, along a dry water-course, lies the settlement of Mohlaletse.

◄ Carrying water, Operation Hunger garden, Mohlaletse, Sekhukhuneland

▲ *Harvesting a communal field, near Ngoabe, Sekhukhuneland*

▶ *Threshed millet, Madebong village, Sekhukhuneland*

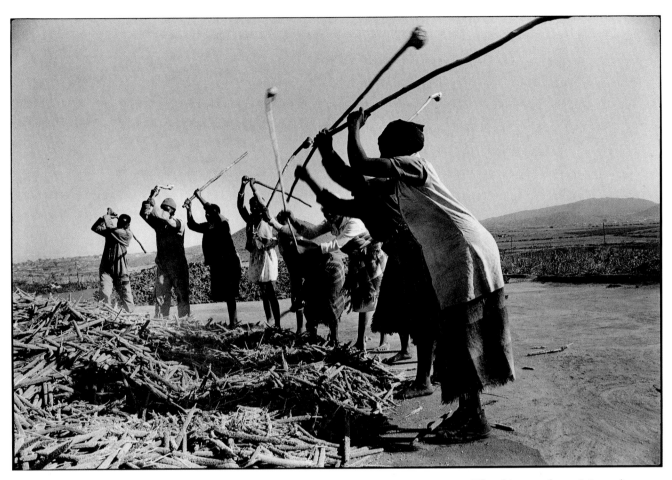

▲ *Threshing sorghum, Moretsele garden, Sekhukhuneland*

◄ *Winnowing threshed sorghum, Moretsele garden, Sekhukhuneland*

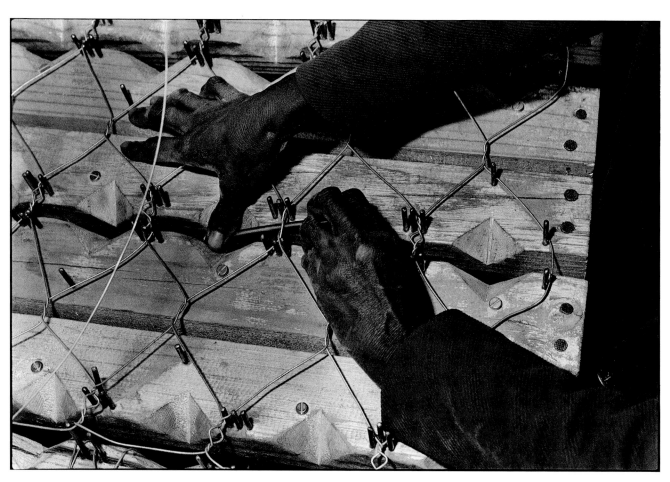

Making wire fencing at Ngoabe clinic,
Sekhukhuneland

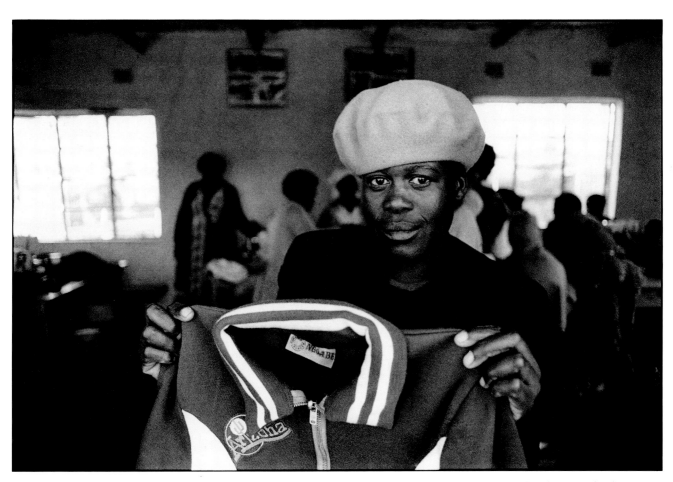

Clothing produced at Ngoabe clinic,
Sekhukhuneland

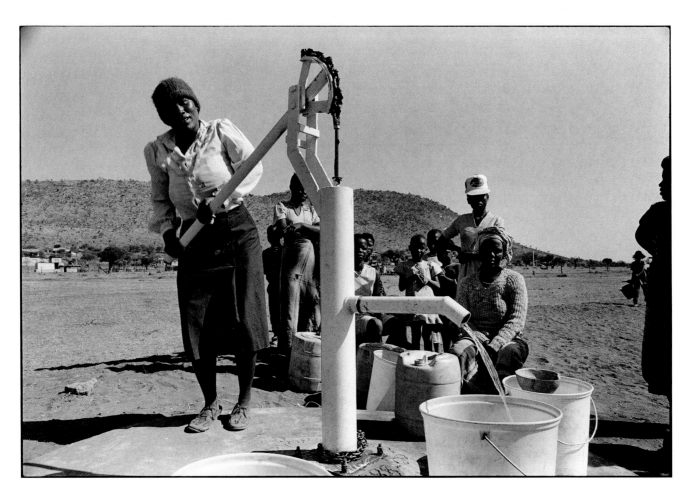

Newly installed pump, Mayebe,
Mohlaletse, Sekhukhuneland

Here Johann and his team have been helping the villages get vegetable gardens going.

Village women get together in groups to develop plots of land granted them by the chief. Operation Hunger sees that a borehole is sunk and a hand-pump installed. Since a lot of water usually goes to waste around a pump, Johann has designed a foundation with a sump to collect this excess water. Because the whole settlement lies along a river-bed, almost every borehole strikes water. So far there are 76 working boreholes and vegetable gardens at Mohlaletse.

When the pump is in place, the women fence the plot (using Ngoabe fencing) and lay out beds. Operation Hunger then gives them the seed to establish their gardens. The project gives them fresh vegetables, a reliable water supply, money from the sale of produce and a communal meeting-place.

Johann and Belinda say that this last factor may be the most important part of the whole project. Women meet at the pump each day and, in talking, discover that the problems which trouble them are not unique to themselves. In discussion they find solace and, often, solutions. This, together with the better diet from the fresh vegetables, has changed the morale of the community.

Indeed, so it seems to me, for the people I see at the pumps are not the poor, dispirited people I saw on previous visits. These people are cheerful, bouncy and full of life. It is a triumphant vindication of Ina's drops-in-the-ocean concept: that to do something, however

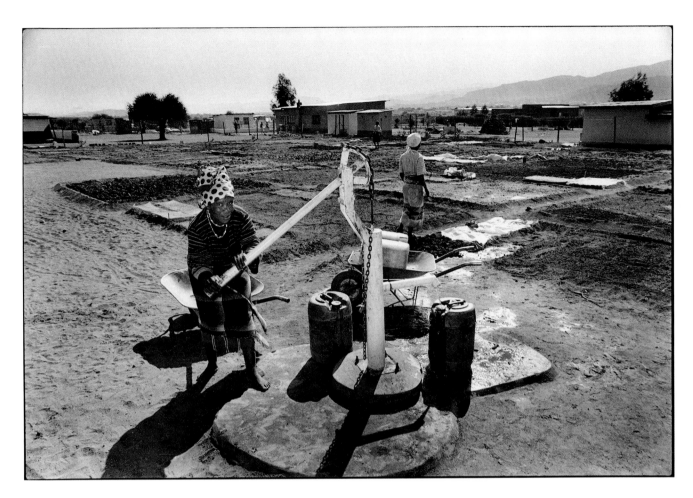

small, is better than to do nothing. For the small beginnings spread and better morale is infectious. Gradually Operation Hunger is bringing new life to this area of Sekhukhuneland.

Peter Magubane, ex-*Drum* photographer and now a distinguished photojournalist for Time-Life publications, said to me a while ago: 'I've stopped taking pictures of downtrodden blacks. I feel I must now take pictures which show my people as confident, determined, competent and able to run a modern industrial country like South Africa.' Since he said this to me I have followed his example. I found it wasn't difficult. Confidence, determination and competence, even in the face of daunting adversity, abound, whether in Port Elizabeth's Soweto squatter camp or in Jane Furse. This (in the words of Lord Moran) 'cold choice between two alternatives; the fixed resolve not to quit' is a triumphant affirmation of the human spirit. It is the most enduring gift I have received from my three-year odyssey with Operation Hunger.

Pumping water for new planting, Malayeneng, Mohlaletse, Sekhukhuneland

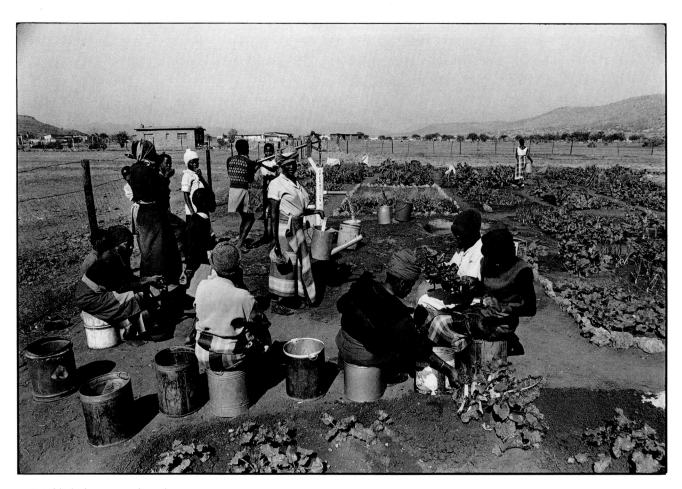

▲ *Established pump and garden,*
Makweng, Mohlaletse,
Sekhukhuneland

▶ *Women with produce grown in*
Operation Hunger garden, Mohlaletse,
Sekhukhuneland

▼ *Weeding of Operation Hunger*
garden, Mohlaletse, Sekhukhuneland

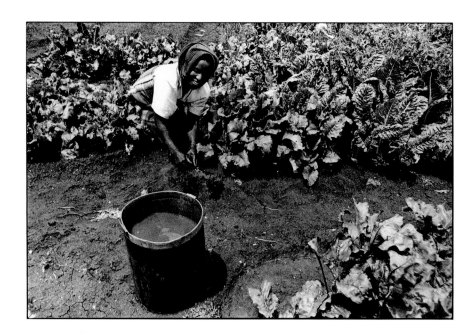

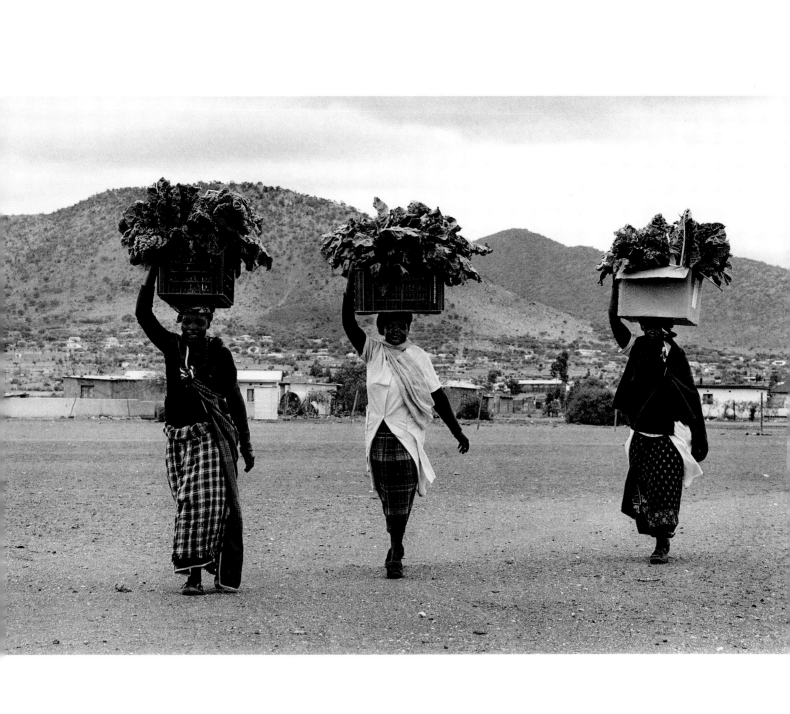

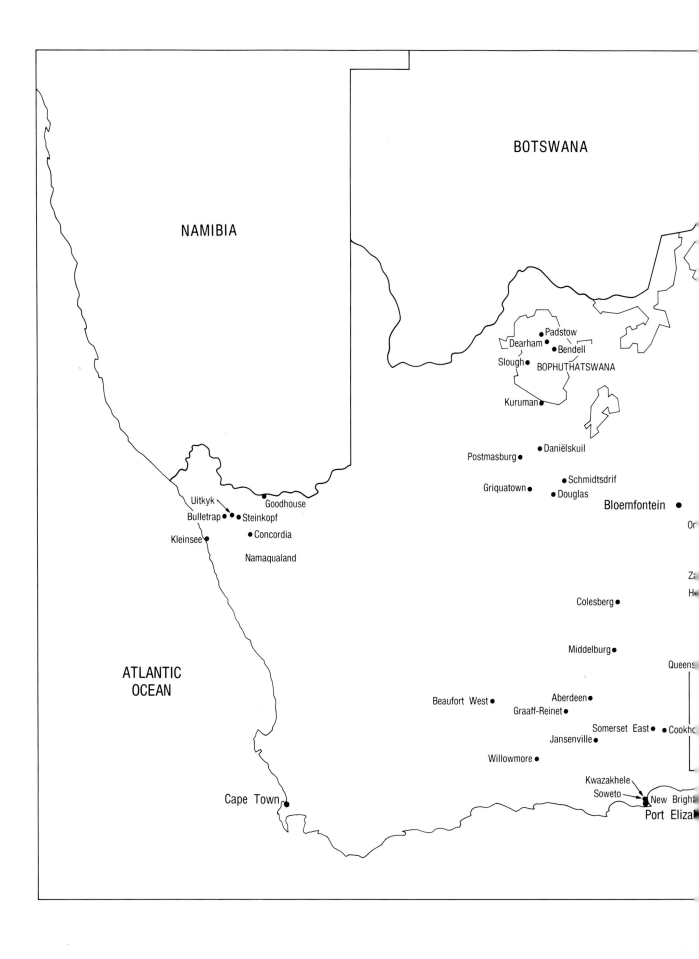

BOTSWANA

NAMIBIA

Padstow
Dearham • • Bendell
Slough • BOPHUTHATSWANA

Kuruman •

Daniëlskuil •
Postmasburg •

Schmidtsdrif •
Griquatown • • Douglas

Bloemfontein •

Or

Uitkyk
Goodhouse •
Bulletrap • • • Steinkopf
Kleinsee • • Concordia
Namaqualand

Za
H

Colesberg •

Middelburg •

Queens

ATLANTIC
OCEAN

Beaufort West • Aberdeen •
Graaff-Reinet •

Somerset East • • Cookh

Jansenville •

Willowmore •

Kwazakhele
Soweto New Brigh
Cape Town •
Port Eliza

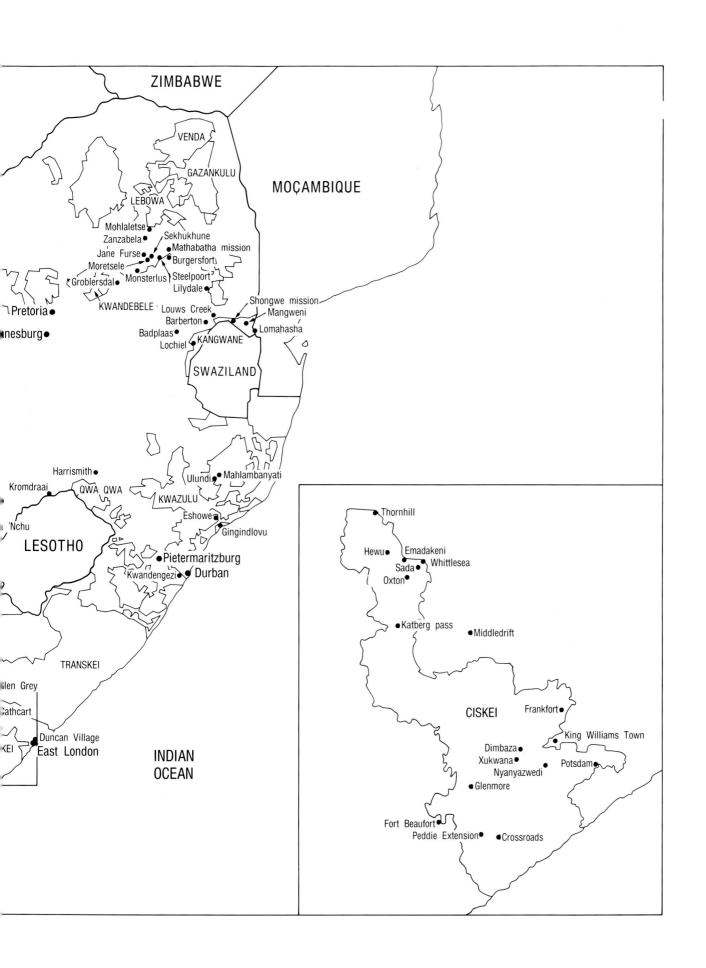